709 Matisse, Henri, 1869-1954.
.2 Matisse / general editor, José Maria Faerna ;
Matis translated from the Spanish by Teresa Waldes. --New
 York : H.N. Abrams, 1995.
 64 p. : ill. (some col.). --(Great modern masters)

 724892 LC: 94036573 ISBN:0810946858

 1. Matisse, Henri, 1869-1954 - Catalogs. 2. Matisse,
 Henri, 1869-1954 - Criticism and interpretation. I.
 Faerna, José Maria. II. Title

1355 95SEP14 3574/ 1-398970

Henri-Matisse

Great Modern Masters

Matisse

General Editor: José Maria Faerna

Translated from the Spanish by Teresa Waldes

ABRAMS/CAMEO

HARRY N. ABRAMS, INC., PUBLISHERS

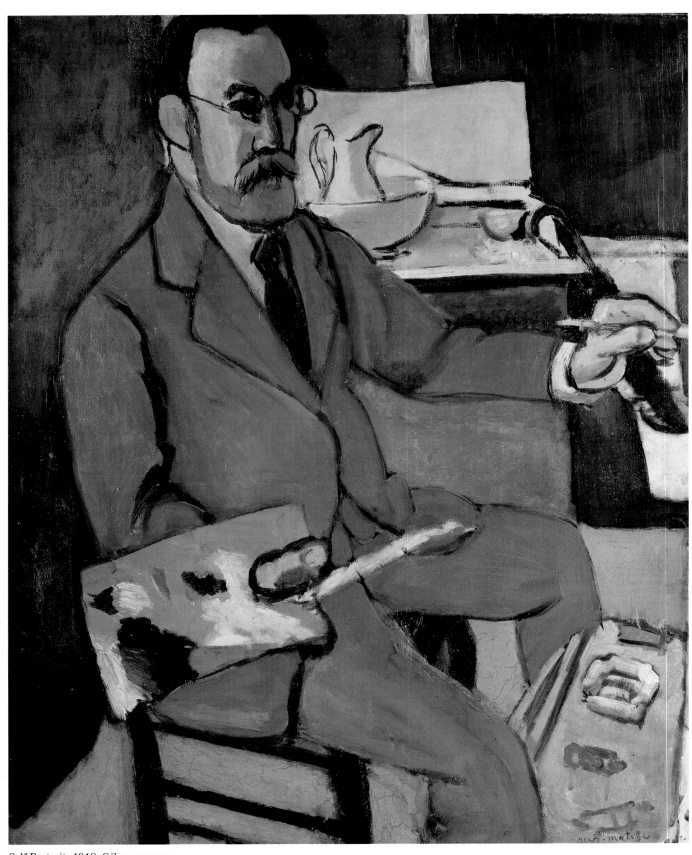

Self-Portrait, 1918. Oil on canvas,
25½ × 21¼″ (65 × 54 cm). Musée
Matisse, Le Cateau-Cambrésis

Matisse and the Fauves

Although the long career of Henri Matisse spanned the entire first half of the twentieth century, art history ties him most closely to Fauvism, one of the movements giving vitality to the French artistic milieu in the first decade of the century, before the appearance of Cubism. In those years a number of young painters were beginning their careers in Paris under the influence of Paul Cézanne and the Post-Impressionists. They sought to free themselves from the pictorial language that had been established by Impressionism.

A group of these young artists had spent time at the studio of the Symbolist painter Gustave Moreau, who favored exotic and decorative subjects, but who encouraged his students to develop their own individual personalities. There Matisse met Charles Camoin, Henri Manguin, Albert Marquet, and Georges Rouault. Later this group was joined by Georges Braque, André Derain, Kees van Dongen, Raoul Dufy, Émile-Othon Friesz, Jean Puy, and Maurice de Vlaminck.

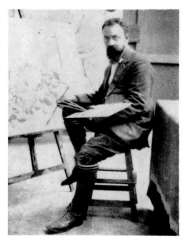

Matisse at work on the painting Still Life with "Dance" *in his studio at Issy-les-Moulineaux, near Paris, in 1909.*

Arbitrary Color

To a greater or lesser degree each of these artists developed a very free style of painting, using vibrant, arbitrary color—that is to say, color independent from the actual hue of the object represented in the picture.

In the 1905 Salon d'Automne several works by Camoin, Derain, Manguin, Marquet, Matisse, and Vlaminck were shown together in one gallery, surrounding an Italianate bust by another artist. The daring of their ideas caused the expected reaction when Louis Vauxcelles, art critic of the magazine *Gil Blas*, exclaimed: "Tiens! Un Donatello parmi des fauves!" (Look! A Donatello among the wild beasts!), thus christening the group.

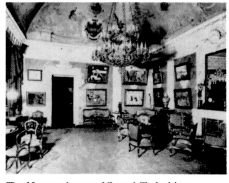

The Moscow home of Sergei Shchukin, early collector of Matisse's work, who commissioned the panels Music *(plate 25) and* Dance (II) *(plate 26) in 1910.*

A Short-Lived Group

There was behind Fauvism no other theoretical argument than its radical and arbitrary colorism. Unlike the great avant-garde styles that appeared after 1910, it was never meant to be an organized movement (though it was perceived as such by critics and the public). Perhaps for this reason Fauvism had effectively ended by 1907, and later its former members followed divergent paths. But until Cubism came to the fore of the Parisian artistic scene in the years just before World War I, Fauvism was the most advanced artistic movement of the time.

Matisse's colleagues at the 1905 Salon d'Automne considered him their leader; not only was he the most gifted painter among them but he was also the oldest and had a somewhat professorial demeanor. (For these latter reasons, Derain asked him in 1901 to visit his parents and persuade

Matisse and his children horseback riding in Clamart, around 1910.

Matisse (right) with the German painters Hans Purrmann and Albert Weisberger in Löwenbräu, Munich, in 1910.

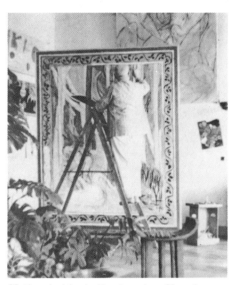

Matisse in his studio at work on Nymph in the Forest (La Verdure) *(plate 55), one of his last forays into mythological painting, c. 1940–41.*

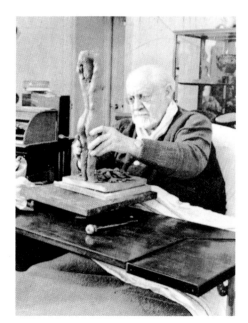

Matisse making a plaster sculpture in his last years, when often he could work only in bed.

them that painting was a respectable calling.) Although Fauvism was a brief episode in Matisse's career, the interests and concerns raised in those years would remain in his work until the end of his life.

Purity of Means

In later years, Matisse would point to "the courage to return to the purity of means" as the "starting point" of Fauvism, and this is exactly what it meant for his art: a place to begin, and from which to extend the legacy of Cézanne, Paul Gauguin, Vincent van Gogh, and the Post-Impressionists. While Vlaminck and Dufy were more interested in the "wild" and expressive aspect of Fauvism, the liberation of pure color opened to Matisse a way to free painting from the depicted object, conceiving of the picture as a colored surface organized according to its own rules and tending toward the "decorative," in the highest sense of the word. Far from wanting to provoke, Matisse said, "What I dream of is an art of balance, purity, and serenity devoid of troubling or depressing subject matter . . . a soothing, calming influence on the mind, something like a good armchair which provides relaxation from physical fatigue." After 1907, his goals were more closely related to those of painters like Pierre Bonnard than to his former companions, some of whom did not realize Fauvism's full potential, as with Vlaminck, or who later followed other directions—like Braque, who went on to collaborate with Picasso in the invention of Cubism; or like Derain, who also inclined toward Cubism, though to a much lesser extent.

Fauve color was of decisive importance for the German Expressionists of the Brücke group after 1910, as it was for some members of the Russian avant-garde before the October Revolution of 1917. After that period the impetus in modern art shifted to those vanguard movements that sought a transformation of the social and cultural environment—Futurism, Dada, Surrealism, the Bauhaus. Matisse, remaining within the limits of painting, pursued a discreet middle course that seemed never to be disturbed by the cataclysmic events of the century. He became in this respect a counter-image to Picasso.

Matisse's Legacy

Matisse's reputation is perhaps higher now than ever, thanks in part to his influence on American painting after World War II. In the postwar era, the principle, espoused by Hans Hofmann, that color is responsible for the structural configuration of the picture became essential for much of American abstract art, as in the work of Mark Rothko, Ad Reinhardt, Barnett Newman, and the Color Field painters. In this context, Matisse is the decisive figure for twentieth-century painting. His principal legacy is to have defined a purely pictorial language of color and arabesque line for the modern age, as opposed to the idea of painting as a means to an end, which was the prevailing view for much of the historic avant-garde.

Henri Matisse / 1869–1954

Matisse's artistic vocation was slow to emerge. He was born in 1869 in Le Cateau-Cambrésis, in northern France, into a provincial middle-class family. He began a career in the law after taking his degree in Paris and worked as a clerk in a law office for a few years. His mother's gift of a paintbox to amuse him as he convalesced from appendicitis in 1890 changed his destiny. The following year he returned to Paris to prepare for the entrance examination to the École des Beaux-Arts. He succeeded in 1895 thanks to Gustave Moreau, whose studio he had attended since 1892, meeting there some of the young artists who would become his companions in the Fauvist adventure.

Formative Years

Before he found a personal style in 1905, Matisse's artistic development was marked by three fundamental influences: Cézanne, with his obsession to restore the structural solidity of the picture, lost since Impressionism; Gauguin, whose Pont-Aven period cannot be ignored if one wishes to understand the mature Matisse; and van Gogh, the first modern painter to liberate color from the actual hue of the depicted subject.

Until Fauvism came into being, Matisse was also for a time influenced by Neo-Impressionism, espoused by Paul Signac. Matisse concluded his exploratory period with *Luxe, calme et volupté* of 1904–5 (plate 8), an Arcadian fable meticulously built up from small, separate touches of pure color, as prescribed by Signac. However, its forced separation of color from line, which seems to form the picture out of two different, overlying constructions, clearly demonstrates the limitations of this approach.

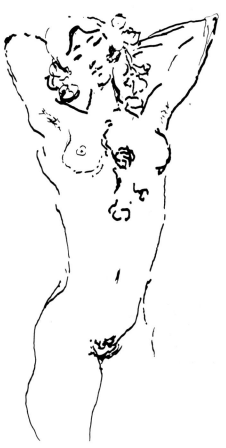

Female Nude, *1905. A study in ink for* Le Bonheur de vivre, *the painting that Matisse completed a year later, marking the end of his Fauve period.*

The Logic of Color

The works painted by Matisse and Derain working together in Collioure during the summer of 1905 ushered in the Fauvist period. *The Open Window* (plate 49) still shows traces of Neo-Impressionism's divided brushstrokes, but the color is much freer and has shed all descriptive duties. The arbitrariness of color was indeed the hallmark of Fauvism, although no one pursued this idea with the depth and rigor of Matisse. Manguin or Vlaminck only "warmed up" the picture with color, choosing the brightest and hottest shades in their palettes, but from the very beginning Matisse used color to build up a new pictorial order, different from nature's own. While he was teaching painting, between 1907 and 1909, he recommended to his pupils that they pursue "the relation between the colors in your picture" more than the direct relation between the picture and the subject: "You are representing the model . . . not copying it." The picture thus became a resynthesis, not simply a direct depiction, of what the artist saw. Signs of this approach already appear in works of 1905, like *Portrait*

Female Nude in the Studio, *1935. This ink drawing recalls the sensuous climate of the* odalisque *paintings executed a decade earlier in Nice.*

Landscape Seen Through a Window, *1912.*
Made shortly after his first trip to Morocco,
this drawing shows the recurring subject
of the window.

Dreaming Woman
in a Blouse, *1936.*
With this drawing
Matisse anticipates
the paintings of
Romanian blouses
executed throughout
the following
decade.

Nude Kneeling Before a Mirror, *1937.*
The subject of the painter and his model
pervades Matisse's work.

of Madame Matisse (The Green Line) (plate 9), where the whole surface is enlivened by the tension between the various harmonies of complementary colors.

Decorative Panels

Beginning with *Le Bonheur de vivre* of 1906 (not reproduced), Matisse quickly developed the new style; it culminated in the panels entitled *Music* and *Dance (II)* of 1910 (plates 25, 26), where the integration of form with color is achieved with an astonishing economy of means, even more impressive when one considers the large format.

World War I brought Matisse to Collioure again and to Nice. His contacts with Juan Gris in Collioure during 1914 may be the source of certain gestures toward Cubism, such as *The Moroccans* of 1915–16 (plate 38) or *Piano Lesson* of 1916 (plate 39), although for the most part his work of the period remained faithful to the exploration of color. In those years he reworked, both visually and thematically, his trips to Algeria and Morocco of 1906, 1912, and 1913. His reappraisal was reflected later in the *odalisques*, paintings of women in exotic costumes, made in the twenties, or in his growing interest in ceramics, printed fabrics, and wallpaper of repetitive design. Matisse did not merely show these decorative patterns in his paintings, but absorbed them into the overall compositional system of the picture.

In 1930 a commission from Dr. Albert C. Barnes to paint a large decorative mural in Merion, Pennsylvania, allowed Matisse again to indulge his decorative propensities, which had already been amply displayed in *Dance (II)* (plate 26). It is not a coincidence that the subject chosen would be the same; the reference to musical rhythms could not be more appropriate to a picture conceived in terms of color harmonies and linear rhythms. Here Matisse used for the first time the technique of colored paper cutouts, albeit at this time only as studies. Beginning with the illustrations for the book *Jazz* (plates 64–69), which he started in 1943, cutouts from paper colored with gouache were at the center of Matisse's artistic activity during the last ten years of his life. This method of "cutting directly into color" allowed him, as he put it, to "draw with scissors," uniting line and color, contour and surface, and thus bringing to a logical conclusion his conception of the picture as a synthesis—which had been a guiding principle of his career for more than four decades.

Last Years

In the years before his death in 1954, Matisse's career culminated in his designs for the Chapel of the Rosary at Vence. There he could finally attempt an integrated decorative program seeking the ultimate unity of visual elements—color, light, drawing—which had always fascinated him in the frescoes of Giotto. Matisse's paper cutouts, as well as the designs for the chapel, were executed by an artist who was now old and chronically ill, often forced to work from his bed. The intensity of the last works does not pale next to his youthful oeuvre; they are still stirred by the same concerns that shaped one of the most consistent yet richly diverse artistic careers of our century.

Plates

Before Fauvism

Matisse's earliest works, those before 1900, were still lifes, reflecting his interest in the eighteenth-century French painter Jean-Baptiste Chardin, or the seventeenth-century Flemish artists. In the first years of the century, he used clearly evident brushstrokes as building blocks in a nude (plate 5), influenced by Cézanne. From 1903 on, the technique of small, separate touches of pure color, organized according to the Neo-Impressionist theories of Paul Signac, and the depiction of light-filled Mediterranean subjects took on great importance, culminating in *Luxe, calme et volupté* (plate 8). The exhibition of this painting in 1904 brought fame to Matisse a year before the advent of Fauvism.

1 The Dinner Table (La Desserte), *1896–97. The first of Matisse's works to be exhibited at the Salon. That same year he was able to see for the first time the collection of Impressionist paintings bequeathed to the French state by the artist Gustave Caillebotte.*

2 Still Life with Books, *1890. The influence of Chardin's still lifes is plainly visible in these early works.*

3 La Desserte (after Jan Davidz. de Heem), *1893. Copying the Old Masters in the museums was an essential step in the academic training of painters.*

4 Interior with a Top Hat, *1896. Dark hues predominate in Matisse's early works.*

1

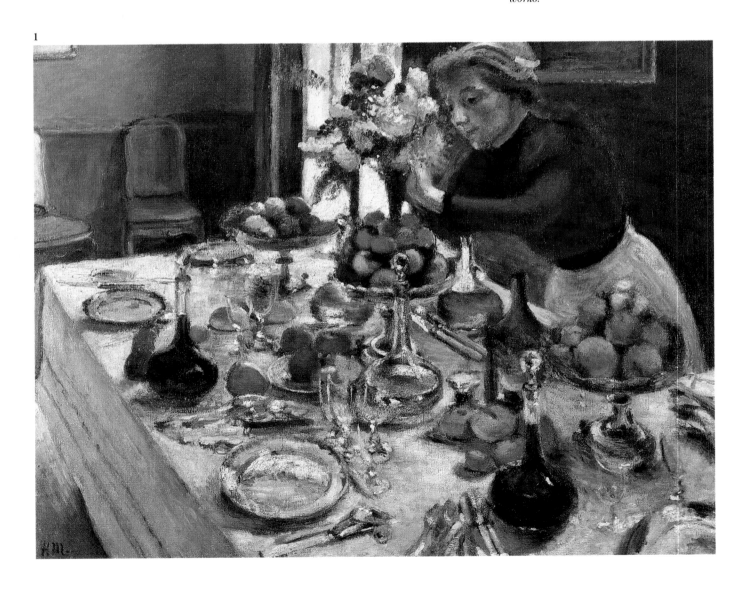

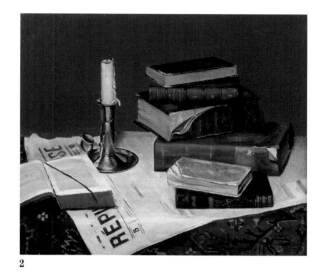

2

3

4

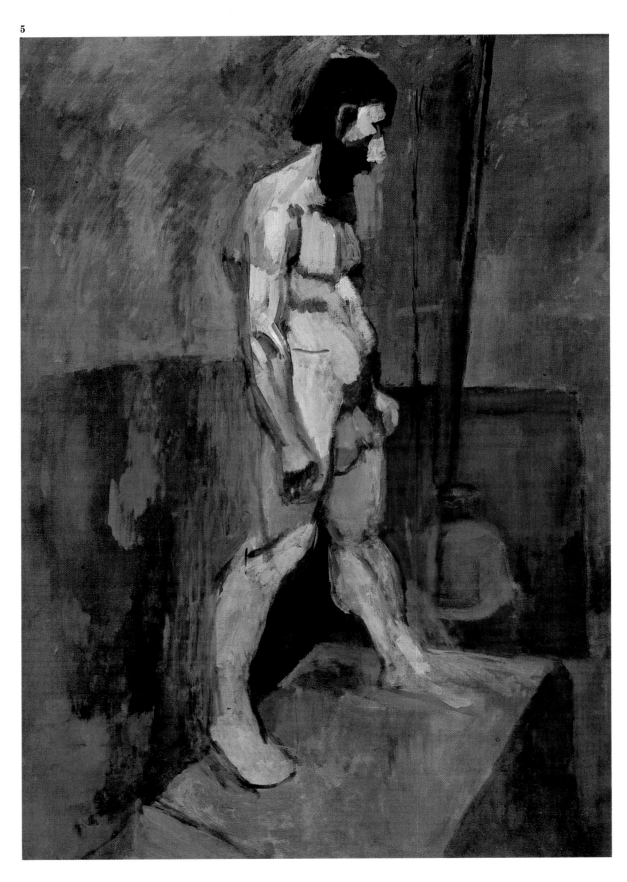

5 Male Model, *c. 1900. The interaction of brushstrokes and patches of color conveys a sense of space and volume in the manner of Cézanne. The previous year Matisse had bought a picture by Cézanne at Ambroise Vollard's art gallery.*

6 Girl with a Parasol, *1905. Matisse met Paul Signac in 1904 and his work went through a brief Neo-Impressionist phase.*

7 La Japonaise (Woman Beside the Water), *1905. An example of the widespread influence of Japanese prints on European art.*

8 Luxe, calme et volupté, *1904–5. The title, taken from a poem by Charles Baudelaire, suggests the atmosphere of a Mediterranean mythological fable. In this work, purchased by Signac, Matisse refines his use of Neo-Impressionism, a style he would abandon the following year.*

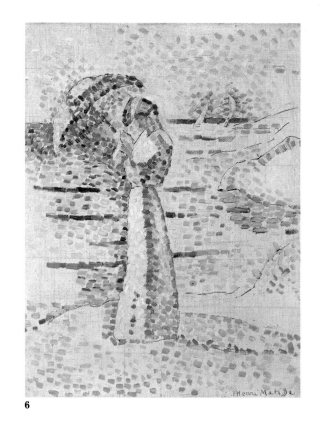

6

7

8

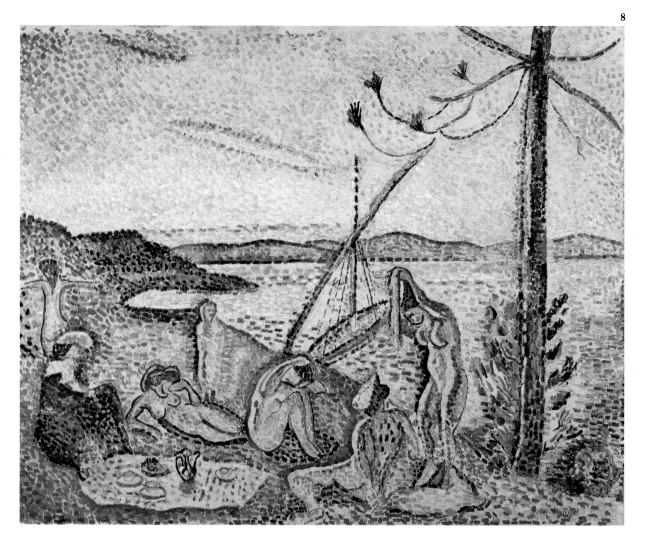

The Liberation of Color

With the development of Fauvism in 1905, Matisse changed the course of his career. Beyond the use of pure colors unrelated to the actual hue of the subject, so scandalous to traditional artistic taste, he was also interested in the emerging possibilities of composing the picture as a whole by chromatic means—through the interaction of juxtaposed areas of color. Thus, in the portrait of Madame Matisse known as *The Green Line* (plate 9), the yellow half of the face appears to be advancing, while the other half recedes toward the green background; likewise, on the left side the red dress blends into a background of the same color, yet the dress sharply contrasts with the green background on the right. The very structure of the picture proclaims its independence from nature's order.

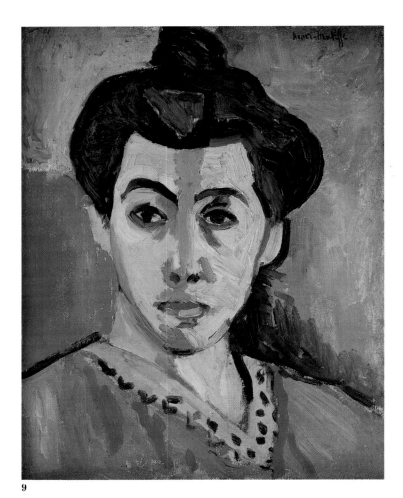

9

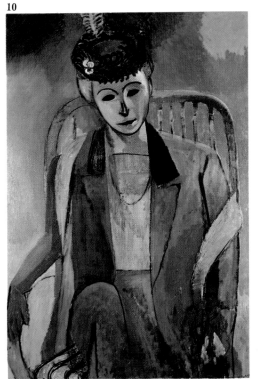

10

9 Portrait of Madame Matisse (The Green Line), *1905. In its freedom of color, this is one of the emblematic images of Fauvism.*

10 Portrait of Madame Matisse, *1913. Seven years after the portrait known as* The Green Line, *the same subject is treated more schematically.*

11 The Woman with the Hat, *1905. This was one of the most shocking pictures exhibited at the 1905 Salon d'Automne; some thought the extravagant colors indicated that the subject was a prostitute. Leo Stein, who once owned this painting, called it "a thing brilliant and powerful, but the nastiest smear of paint I have ever seen."*

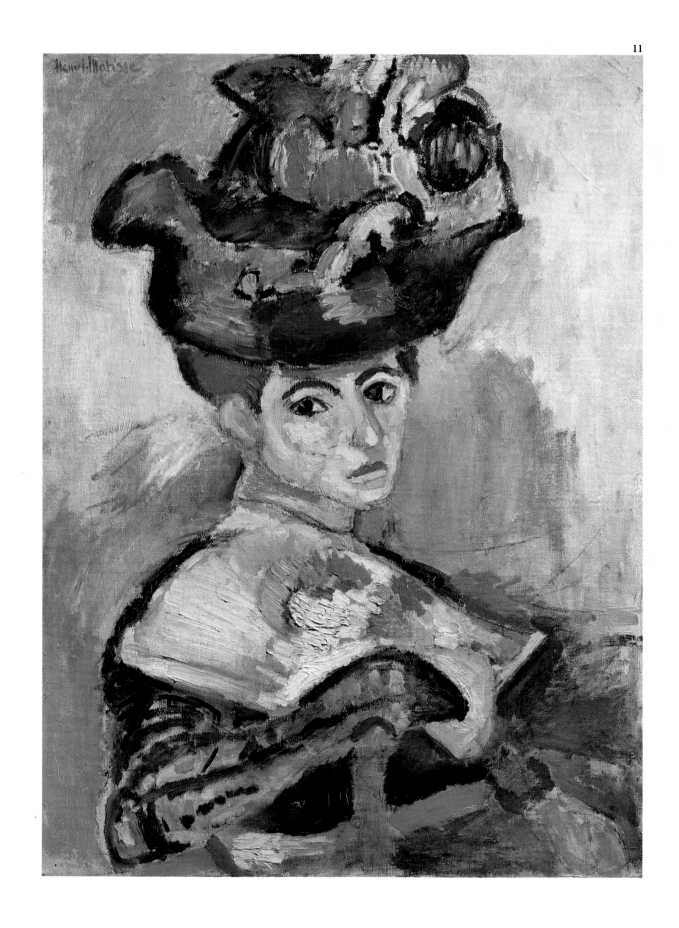

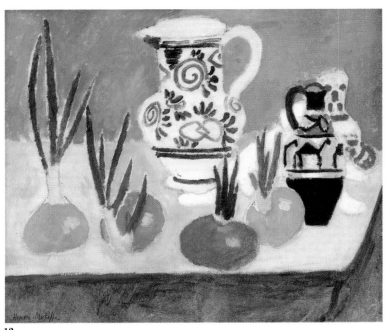

12

12 Pink Onions, *1906. The earthenware vases were bought by the artist in Algeria the same year. The designs that appear on them are the only elaborate elements in what is otherwise an extremely simplified painting.*

13 The Young Sailor (I), *1906. Cézanne's influence is still visible in the structure of the picture and in the attempt to create space and volume by drawing attention to the brushstrokes.*

14 The Young Sailor (II), *1906. A second version of the previous work, the subject is here treated much more flatly; the colored areas almost seem to be cutouts, placed one on top of the other. The hues have become more muted, modifying Matisse's Fauve manner.*

13

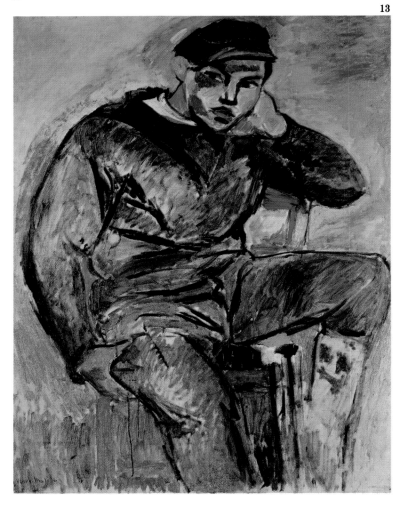

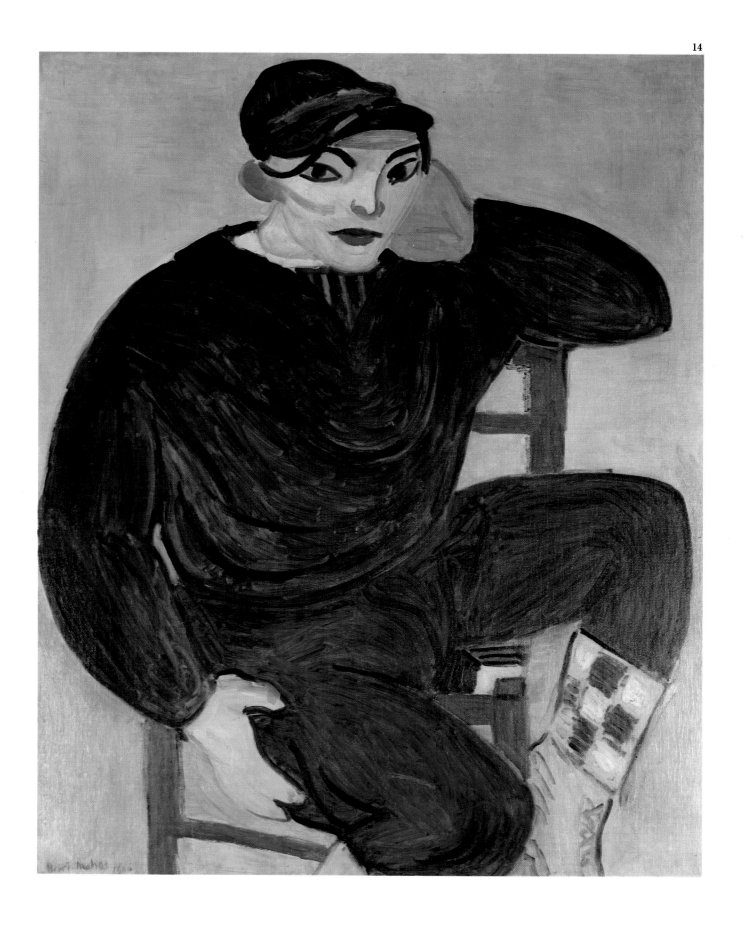

Mediterranean Allegories

In 1906 Matisse painted *Le Bonheur de vivre*, a picture suffused with warm, soft, luminous hues, where the influence of Cézanne's paintings of bathers is transformed into a more lyrical composition. The subject, an allusion to a golden age in a lost Arcadia, relates to Symbolism, which played such an important role in the early years of the century; it continued a thematic line that started with *Luxe, calme et volupté* (plate 8). The bather subject would reappear in the two versions of *Le Luxe* (plates 18, 19) and in three pictures of 1908 and 1909 (plates 15–17) that exemplify a manner ever more simplified, a consequence of the "purity of means" Matisse brought to the Fauve experiment.

15

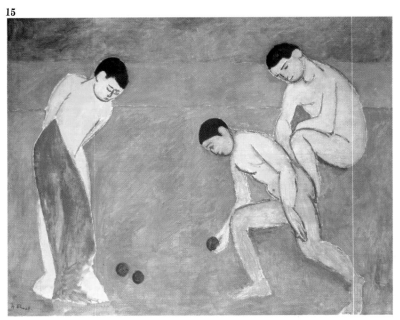

16

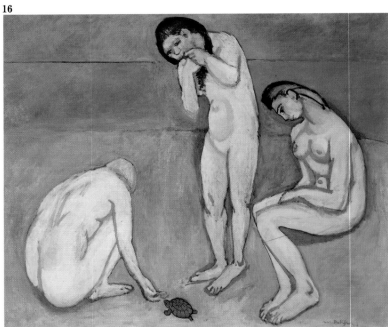

17

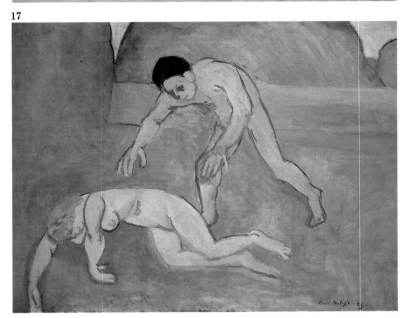

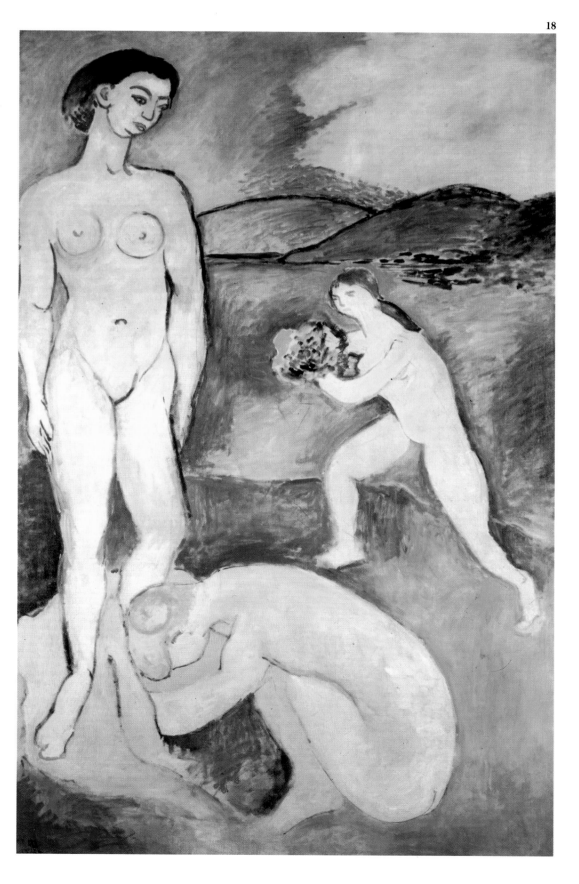

15–17 Game of Bowls, *1908;*
Bathers with a Turtle, *1908;*
Nymph and Satyr, *1908–9. In*
these three small works Matisse
began to abandon the vibrant
hues of Fauvism, replacing them
with flatter, more muted colors.

18 Le Luxe (I), *1907. One of*
Matisse's first experiments with
the large formats appropriate to
decorative panels. The Symbolist
influence of Pierre Puvis de
Chavannes on the subject and
the figures is expressed with a
luminous, almost transparent,
color; however, the paint is still
vigorously applied in the Fauve
style.

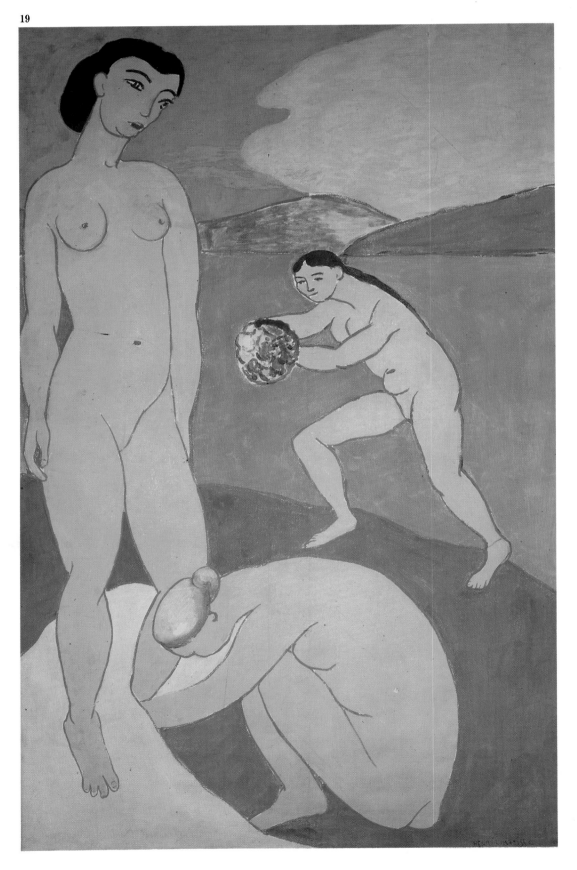

19 Le Luxe (II), *1907–8. In this second version, the composition's decorative monumentality receives a suitable treatment by means of large areas of flat color, with firmly drawn lines organizing the chromatic surfaces.*

Colored Surfaces

After buying textiles and ceramics during his trip to Algeria in 1906, Matisse became more and more interested in decorative patterns, such as those used in printed fabrics, tapestries, rugs, embroideries, wallpaper, and upholstery. Decorative motifs from these sources attracted him because of their flat and repetitive character. Matisse did not simply depict these patterns; he actually incorporated them into the picture as a guide to organizing the surface, making them equal in importance to the three-dimensional objects and the figures that were depicted. *Red Rugs* of 1906 (not reproduced) was the first such picture, but it is with *Harmony in Red (La Desserte)* (plate 20), an abstracted reworking of *The Dinner Table (La Desserte)* of 1896–97 (plate 1), that this decorative aspect of his art became fully established.

20 Harmony in Red (La Desserte), *1908. This work, first executed in shades of green, and then in blue, was finally repainted in red. The floral motifs in the toile de Jouy of the tablecloth and wall are given equal importance with the woman, fruit bowls, decanters, and the landscape.*

20

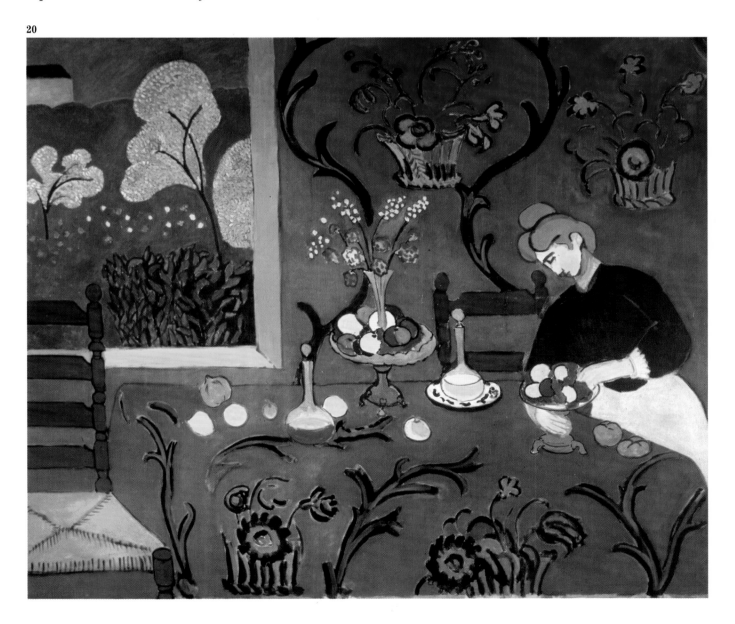

21

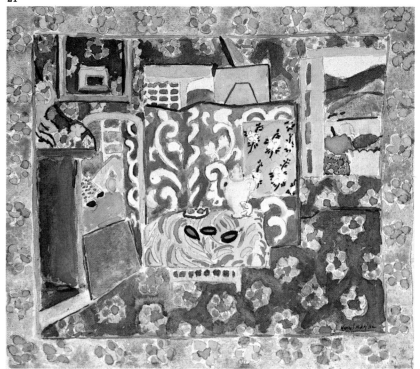

21, 22 Interior with Aubergines *(preliminary watercolor and final canvas), both 1911. In the layering of flat motifs, Matisse composed this picture as one would a tapestry design. This is especially evident in the preparatory watercolor, where a border frames the scene (removed in the final version). The rectangular motif in the center is a Spanish mantilla.*

22

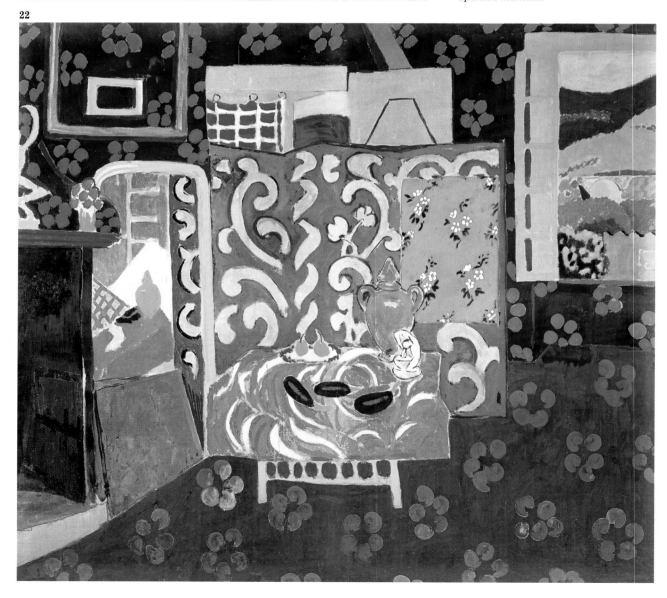

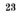
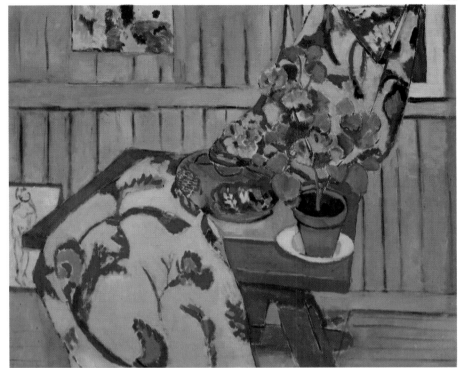

23 Still Life with Geraniums, *1910. The decorative treatment of the blue fabric contrasts with the more conventional character of the geraniums on the table and of the background.*

24 The Painter's Family, *1911. The space inside the room is a surface enlivened by the arabesques of rugs and upholstery. The artist's daughter, Marguerite (in black), his two sons, Jean and Pierre, and Madame Matisse are merely pillars of color that organize the composition.*

24

Dance

Sergei Shchukin, a Russian collector who had already bought *Harmony in Red* from Matisse in 1908, commissioned two large decorative panels for the staircase of his house in Moscow the following year. Taking as his starting point the Arcadian universe of *Le Bonheur de vivre*, and using the decorative, monumental language of *Le Luxe (II)*, Matisse executed *Music* (plate 25) and *Dance (II)* (plate 26) with the greatest economy of means: a harmony of blue and green for the background and a saturated vermilion for the figures, the whole ensemble forming a great symphony of color. The affinity of *Dance (II)* with the choreography created by Vaslav Nijinsky for Igor Stravinsky's *The Rite of Spring* in 1913 has often been pointed out; however, more important is the picture's unification of form and color, never before achieved so successfully in Matisse's painting.

25–27 Music, *1910;* Dance (II), *1910;* Dance (I), *1909. While the static figures in* Music *are positioned like notes on a staff, the figures in* Dance (II), *moving with rhythmic frenzy, press out against the picture's edges with the torsion of their helicoidal spin. It was not the daring of this treatment, however, that worried Shchukin, but rather the subject; he feared that the nude figures were indecorous.*

25

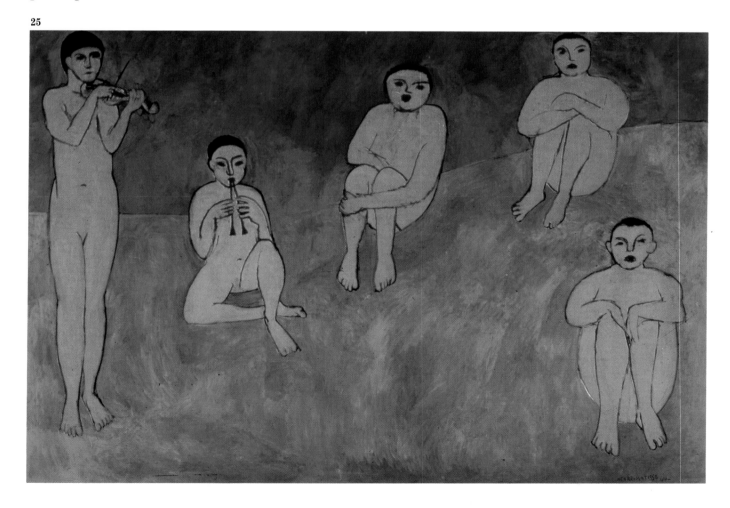

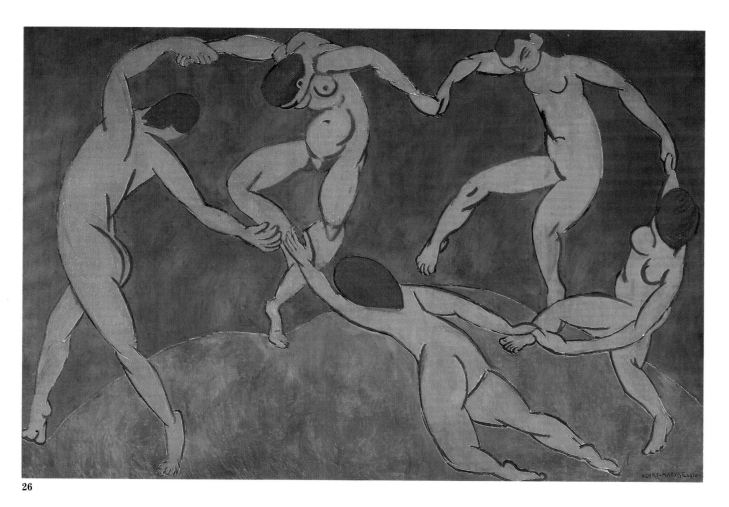

26

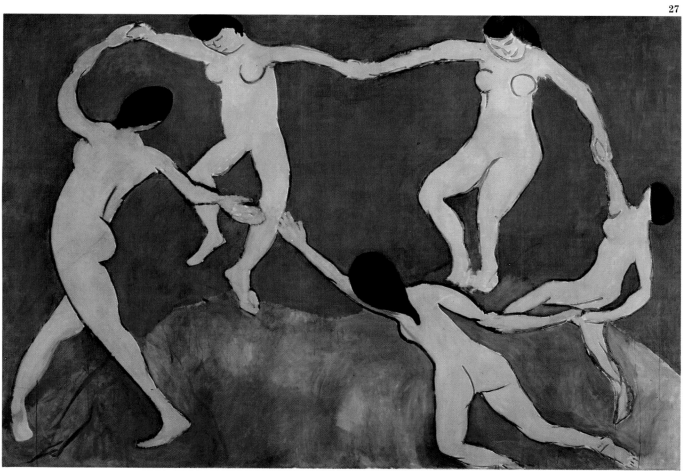

Mural for the Barnes Foundation

Matisse again became interested in the subject of dance when Dr. Albert C. Barnes commissioned him in 1930 to decorate three large lunettes above the windows in one gallery of the Barnes Foundation in Merion, Pennsylvania. Barnes had already bought *Le Bonheur de vivre* from Leo Stein, and was very interested in Matisse's painting. The artist responded enthusiastically to the opportunity to create a work that would be a true decoration—that is to say, inseparable from the space for which it was conceived. Matisse worked intensively for three years, sometimes using colored paper cutouts as studies for the composition. The final painting is an immense chord of pink, blue, and pearl gray on a black background. Matisse worked at full scale, like a fresco painter, without transferring the design from a smaller model on a grid. Explaining this practice, he said: "A man with his searchlight who follows an airplane in the immensity of the sky does not traverse space in the same way as an aviator."

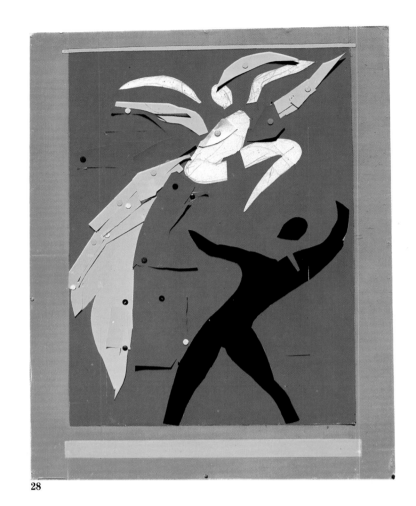

28

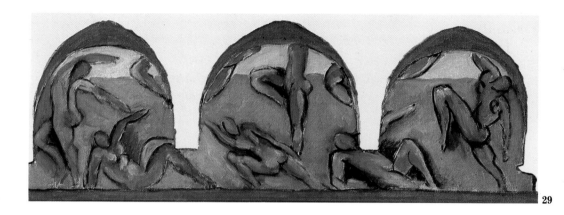

28 Dance, *1938. Eight years after the Barnes commission Matisse returned to the same subject, in small format, in cutouts colored with gouache.*

29 Dance *(oil sketch), 1930. In this preparatory study for the Barnes commission, the colors and composition are different from those actually adopted in the first executed version.*

30 Dance *(first version), 1931–32. A mistake made in measuring the space to be painted forced Matisse to discard his initial attempt and start again. This is the first, rejected version, which differs from the one installed at the Barnes Foundation in the disposition of the figures, but is otherwise quite similar.*

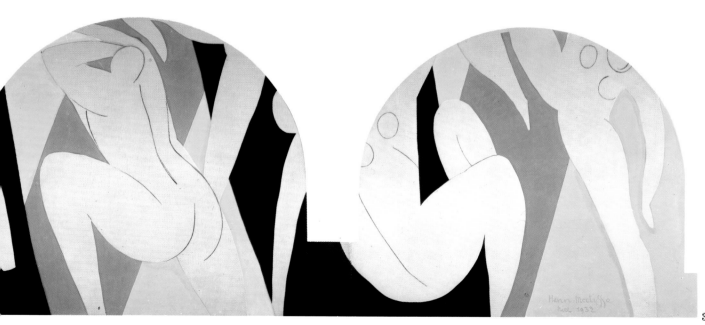

A Fascination with Exoticism

Following a deeply rooted tradition in French painting, going back to Eugène Delacroix and Jean-Auguste-Dominique Ingres, Matisse was sensitive to exotic influences. After traveling to Algeria in 1906, he spent several months in early 1912 in Morocco and returned there for the winter of 1912–13. The fruit of these Moroccan trips are a series of paintings with a luminous treatment of color in very clear and simplified harmonies (plates 31–34). Later, during his stays in Nice in the period between the wars, his memories inspired the *odalisques* (plates 35–37), which present women in fanciful costume within a climate of sensuality and decorative refinement.

31

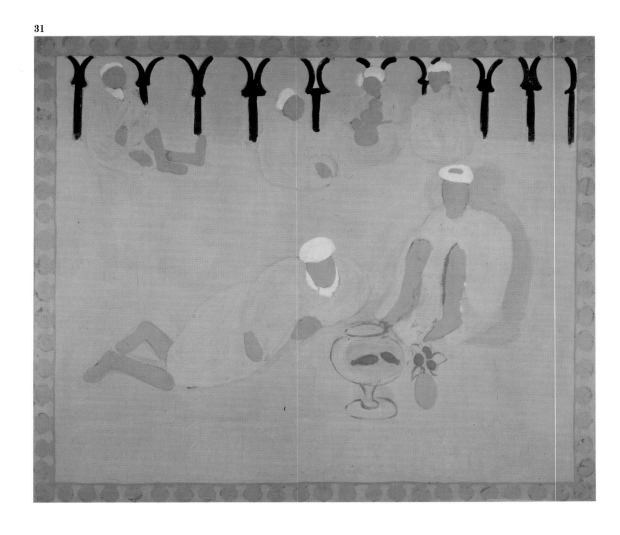

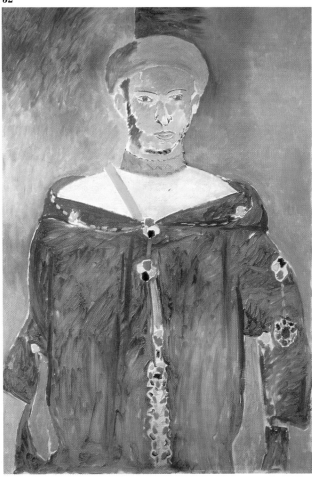

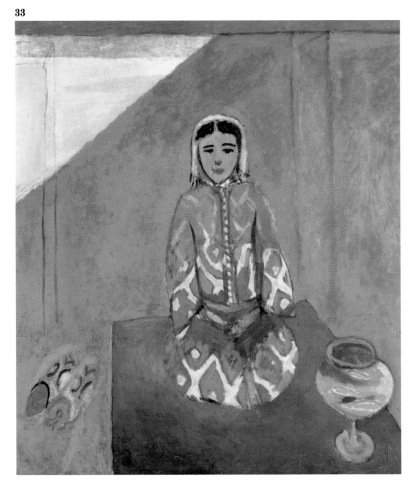

31 The Moroccan Café, *1912–13. This usually bustling and colorful subject on this occasion sinks into an elegant faded green background; the figures float in a fluid and decorative space.*

32 The Standing Riffian, *1913. Again, as in* Portrait of Madame Matisse (The Green Line) *(plate 9), the painter divides the background into two harmonious shades that set off the figure's colors, but here he produces a much flatter result.*

33 On the Terrace, *1912–13. The slippers, the printed dress, and the goldfish accent the delicate harmony of cream, blue, and turquoise in the background.*

34 The Casbah Gate, *1912–13. The blue light of the afternoon suffuses the whole picture, uniting the outside with the inside and dissolving the architectural forms into transparency.*

33

34

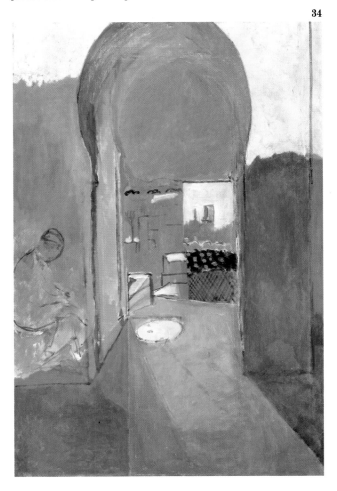

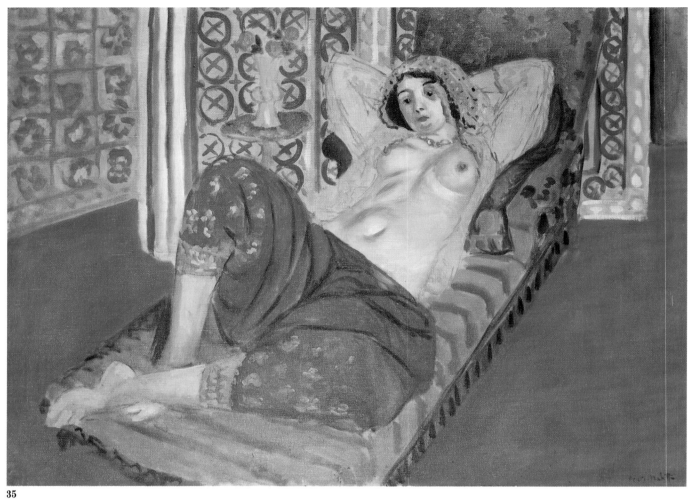

35

36

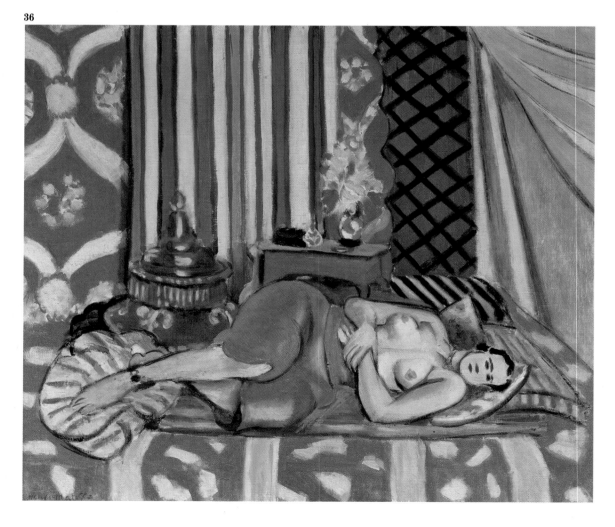

35–37 Odalisque with Red Culottes, *1921;* Odalisque with Gray Culottes, *1921;* Odalisque with Raised Arms, *1923. The model Henriette Darricarrère posed for most of these* odalisques, *which evoke the myth of the woman as object of desire, without responsibilities or consequences.*

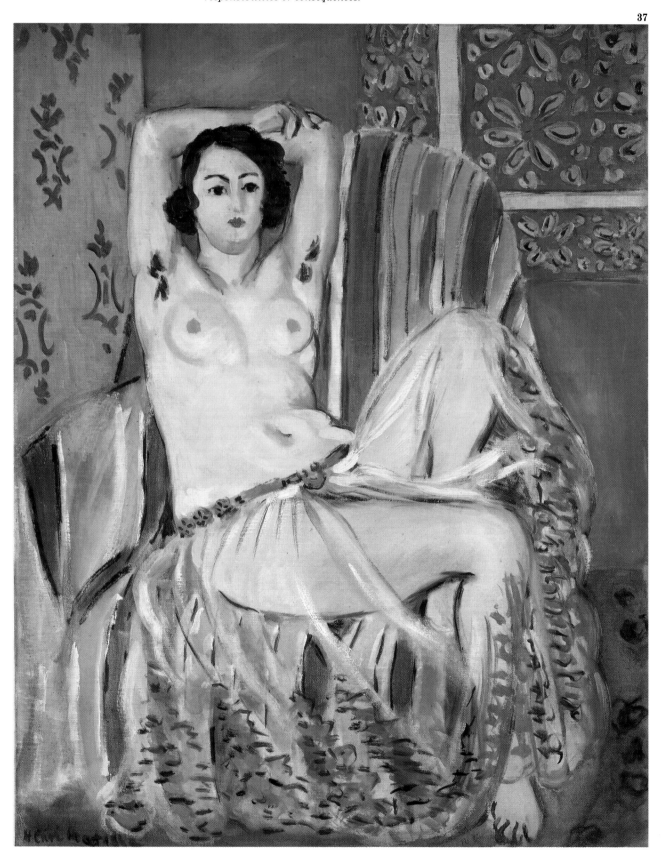

Cubist Echoes

From 1912 on, Cubism triumphed on the French artistic scene. In spite of his relationship with Picasso, whom he had met years before at the home of the American writer Gertrude Stein, Matisse's painting was already on the steady, independent course that it would sustain until the end of his life. Thus, his work was impervious to Cubist innovations as far as the method of representation was concerned. However, perhaps due to his contacts with Juan Gris in Collioure and Toulouse in 1914, a group of paintings dated between that year and 1916 share a certain tendency to simplify the figure into geometric terms. They can be understood as a return to Cézanne's influence in order to answer the new challenge posed by Cubism. Matisse soon abandoned this path, however, whose Cubist reference is more apparent than real, and remained faithful to his own concept of painting.

38

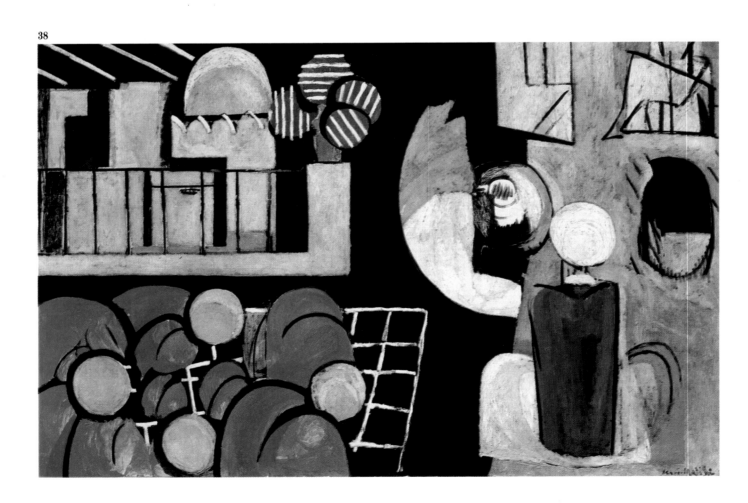

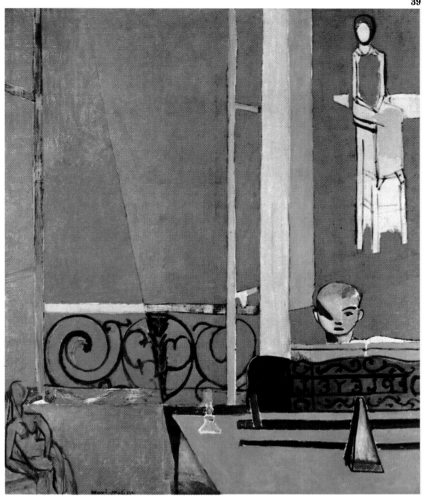

38 The Moroccans, *1915–16. This subject reflects Matisse's trips to Morocco in 1912–13. The geometric treatment of the figures is the only difference from the works of those years.*

39 Piano Lesson, *1916. This is probably the work by Matisse that most closely approximates Cubism, although the interaction of colored surfaces is still the prevailing mode and the space is not at all Cubist.*

40 Bathers by a River, *1909–16. The figures are a late homage to Cézanne's bather paintings, one of which Matisse had purchased at the beginning of his career from the dealer Ambroise Vollard.*

40

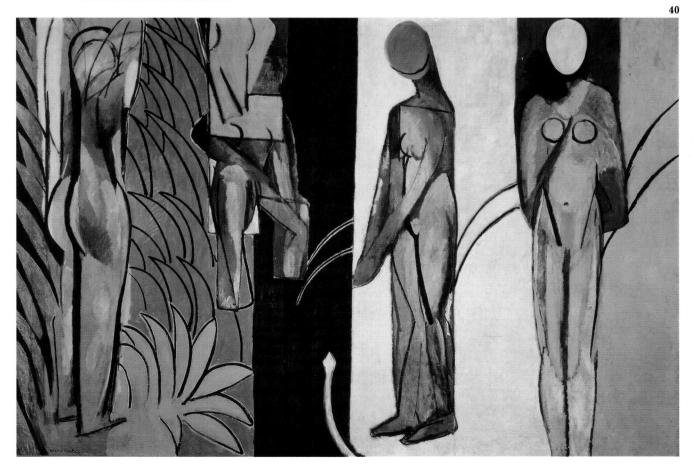

41 French Window at Collioure, *1914. Painted after his departure from Paris at the start of World War I, this work brought Matisse close to abstract art. It inaugurated a period when large black surfaces appear frequently as a background.*

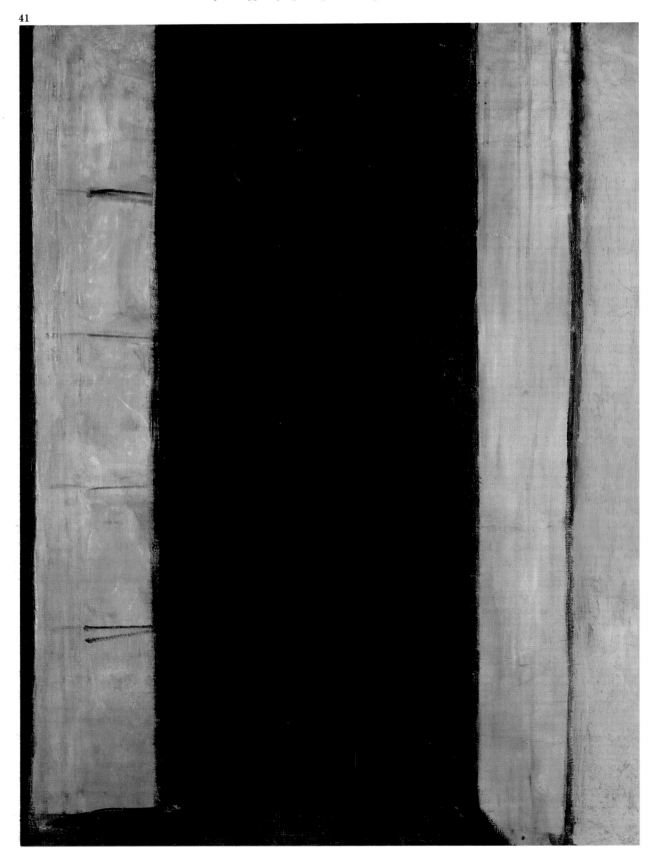

42 The Yellow Curtain, *c. 1915. The lack of geometric stability of the lines in this picture invites an intentional confusion between figure and background, and draws attention instead to Matisse's concept of painting as a harmony of color.*

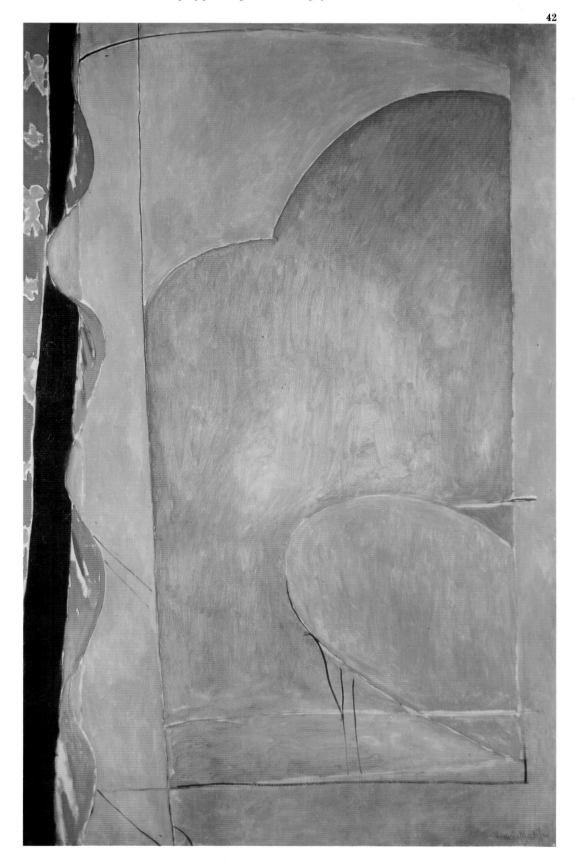

Decorative Languages

During the second decade of the century, while he pursued the simplification of forms, Matisse was still producing decorative and sensuous easel paintings. Works like *Basket of Oranges* of 1912 (plate 44) furthered his interest in printed fabrics. In *The Red Studio* of 1911 (plate 43) Matisse used a single chord of reds to organize the entire surface. The pictures shown hanging in this studio—such as *The Young Sailor (II)* (plate 14) and *Le Luxe (II)* (plate 19)—are in counterpoint with this great, all-encompassing red harmony; they are integrated into the general structure of the picture by becoming a decorative pattern.

43 The Red Studio, *1911. Matisse had settled into his new home and adjoining studio at Issy-les-Moulineaux, a suburb of Paris, a few years previously, when his economic situation improved. In 1909, he had already treated the subject of the picture-within-a-picture in* Still Life with "Dance" *(not reproduced), in the same way as a composer might quote a tune by someone else within a piece.*

44 Basket of Oranges, *1912. Made during a stay in Morocco, this painting would later be owned by Picasso.*

43

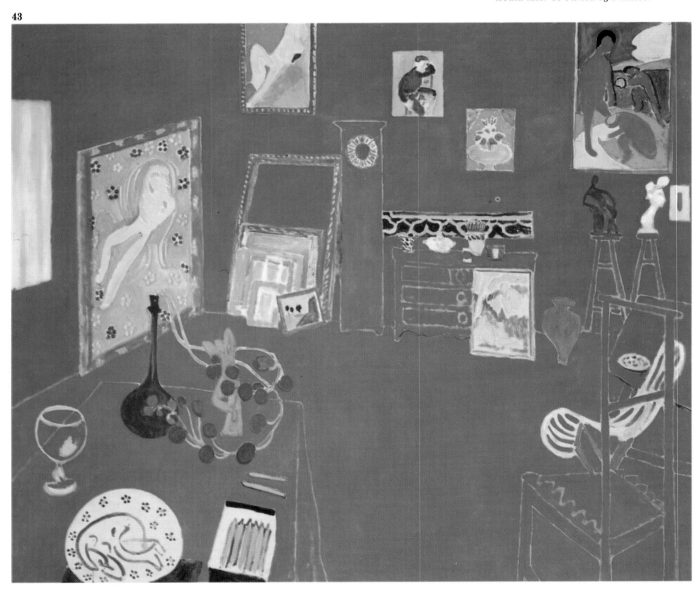

45 Woman in a Turban (Lorette), *1917. Painted in Nice. The elegant softness of its pale hues puts this painting halfway between the pictures with a Moroccan theme and those influenced by Mediterranean light.*

45

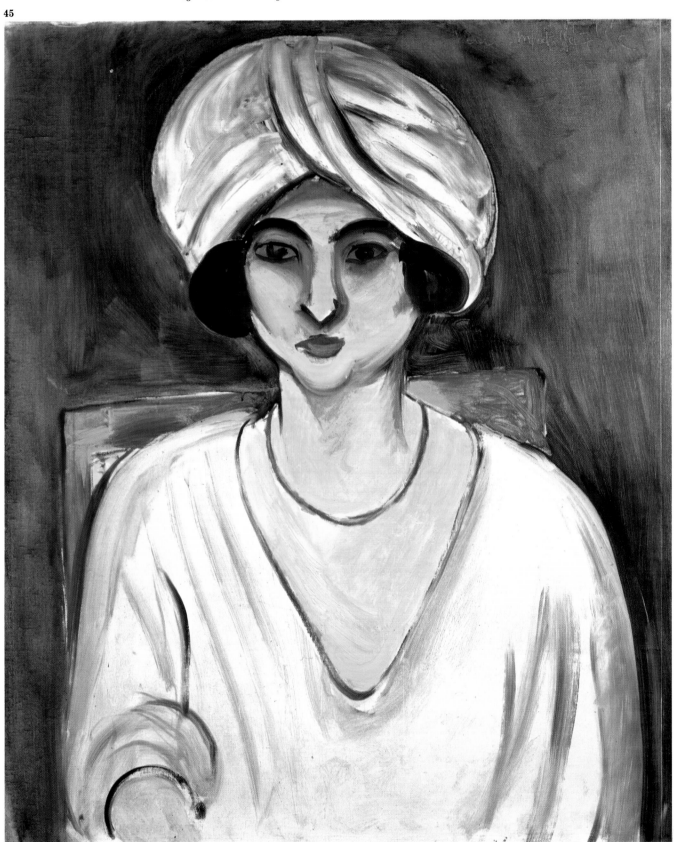

46 Lorette with a Coffee Cup, *1917. Lorette was a model of Italian origin with whom Matisse worked often in Nice. There is another version of this picture where the model appears full-length with her skirt gathered around her thighs, anticipating the languid sensuality of the* odalisques *of the following decade.*

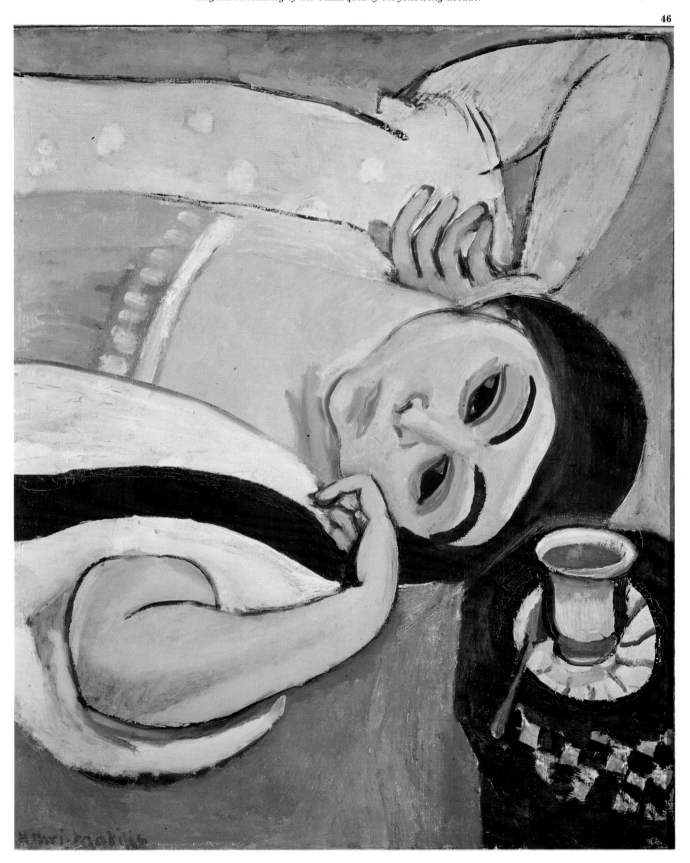

Windows

Almost from the beginning of his career Matisse showed a singular preference for the window as a subject of his pictures. A large number of his interiors include views through windows, balconies, or doors, which allowed him to play with different kinds of light. They show how spatial depth (as seen through a window) is translated to a flat surface (such as a wall)—that is to say, translated into the two-dimensional medium of painting. When asked about the origin of his preference for the window as a subject, Matisse answered: "It probably comes from the fact that for me the space is one unity from the horizon right to the interior of my workroom, and the boat which is going past exists in the same space as the familiar objects around me; the wall with the window does not create two different worlds." Matisse understood pictorial space as an all-encompassing expanse, one which includes both the viewer and the painter; this is true of the easel paintings as well as the large decorative panels.

47 Interior with an Egyptian Curtain, *1948. The large palm tree seen through the window becomes yet another flat decorative motif echoing the curtain at the right.*

48 Large Red Interior, *1948. A single chromatic chord again organizes the entire surface, as in* The Red Studio *(plate 43). The picture on the wall and the space seen through the door receive the same flat treatment.*

49 The Open Window, *1905. This is the first picture in which Matisse undertook the subject of the window. It is almost a manifesto of the integration of interior and exterior space.*

47

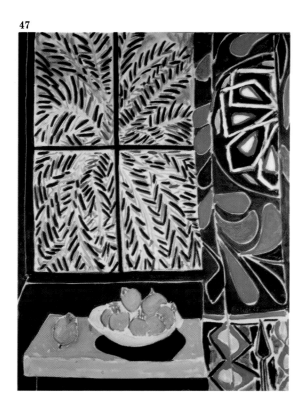

48

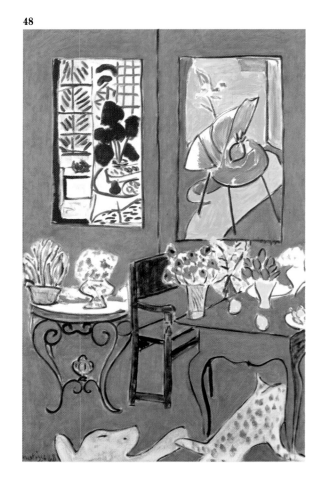

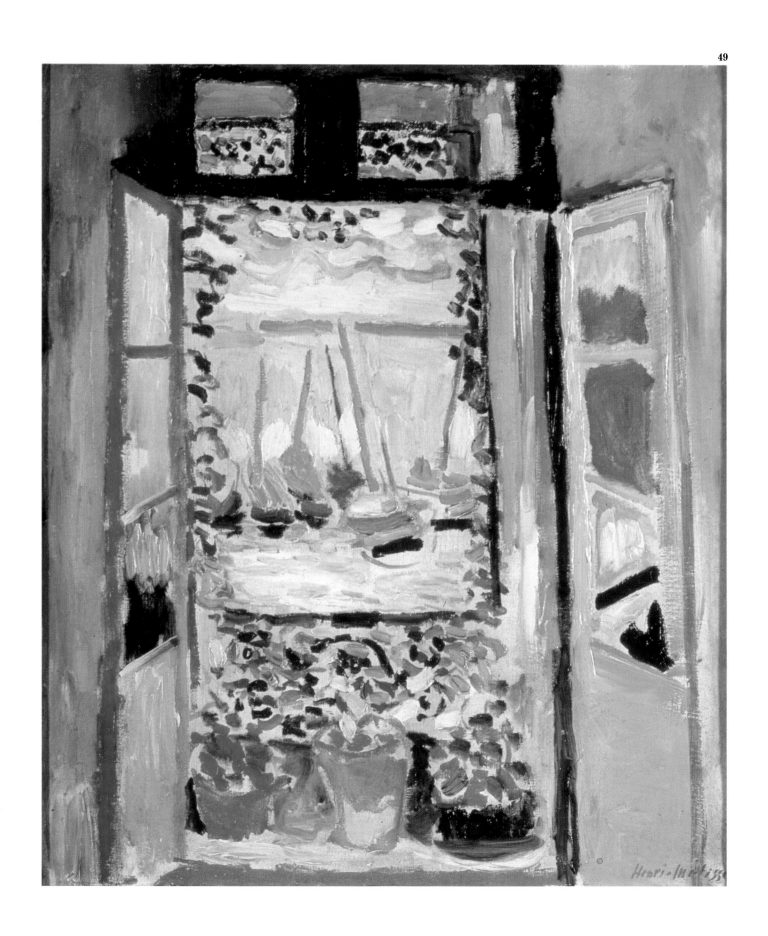

50 Interior with a Violin, *1917–18. The dark, somber hues of the interior contrast with the luminosity behind the shutter. The placement of the shutter and the violin at oblique angles to the picture plane creates a tension between spatial depth and the flat areas of black.*

51 Interior with a Phonograph, *1924. The play of spaces seen through other spaces is carried out by means of differing decorative patterns (such as the Indian hanging, the tablecloth, and the wallpapers), each of which identifies a different space. The painter's head appearing in the background introduces an element of ambiguity, since we do not know whether it is his image, reflected in a mirror, or the artist in some unknown space beyond the hanging.*

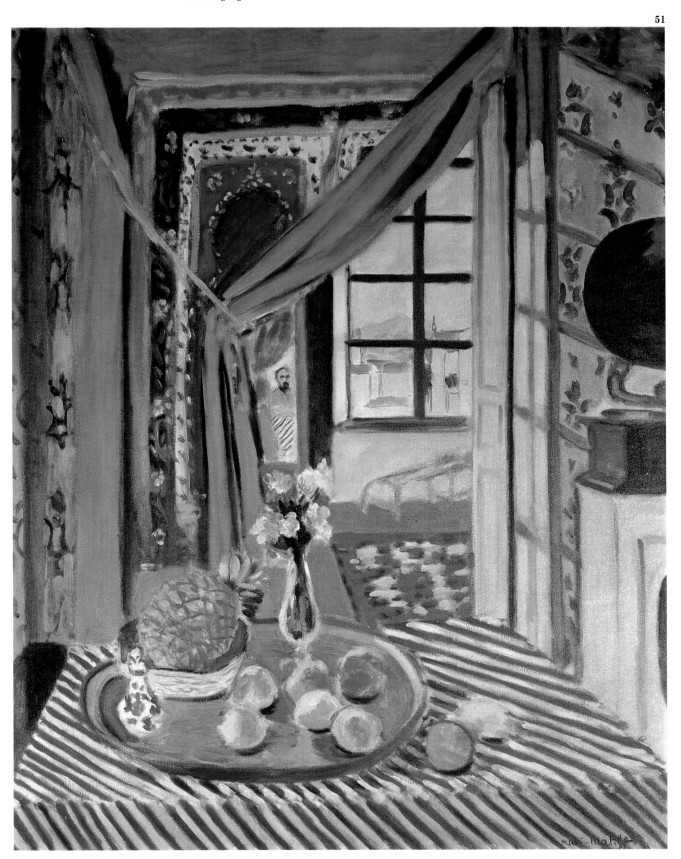

An Unwavering Course

By 1907 all the great themes and concerns of Matisse's career had already made their appearance. Having reached artistic maturity, he continued exploring and extending the path he had chosen from the beginning. This gave his work a certain inner consistency despite the many styles and approaches he developed over the decades: he remained committed to an emphasis on the decorative; to the idea of the picture as a harmonious tension between colored surfaces; and to a painterly style at once sensuous and introspective. Starting in the 1920s, we see a regular reoccurrence of his interest in decorative surfaces (plate 54); his taste for mythological subjects (plates 55, 63); and his singular way of bringing into the picture the decorative patterns of fabrics, embroideries, and prints (plates 56–58). All of these elements are treated with an ever deeper spirit of synthesis and of simplification, which are the two great concepts giving continuity to his career.

52

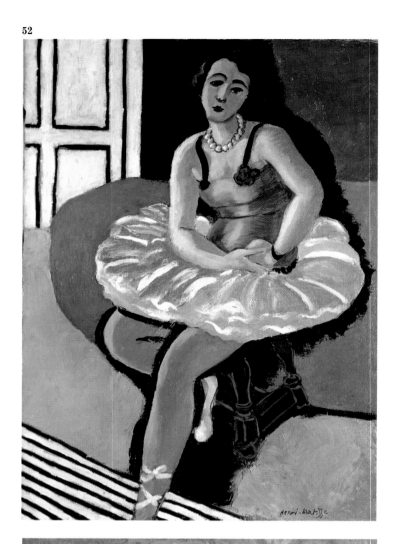

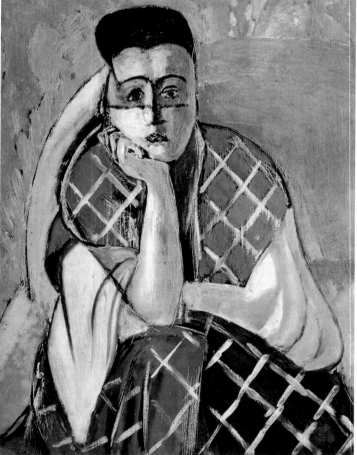

53

44

52 The Ballerina, *1927. Within this picture's cool palette, the blue and black patches framing the figure create a flat space, contradicting the three-dimensionality suggested by the floor and the chair.*

53 Woman with a Veil, *1927. The sensuality of the* odalisques *here finds a more contained and schematic counterpart.*

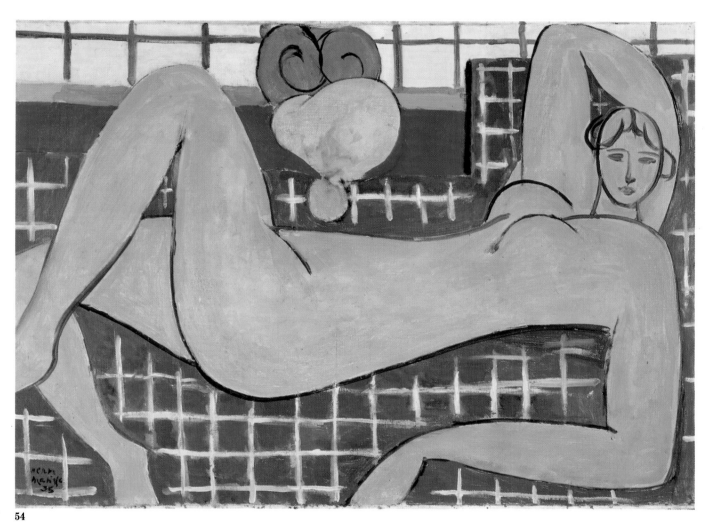

54

54 Large Reclining Nude (The Pink Nude), *1935. Lydia Delectorskaya, Matisse's secretary, confidante, and model at the time, posed for this picture, which brings back the monumentality of the figure first seen in the decorative panels of 1910, albeit in a smaller format. The figure's proportions are manipulated and distorted to adapt them to the frame, while the background is simplified as much as possible. The rendering of volumes has become stylized to the point where they are expressed exclusively in terms of surfaces.*

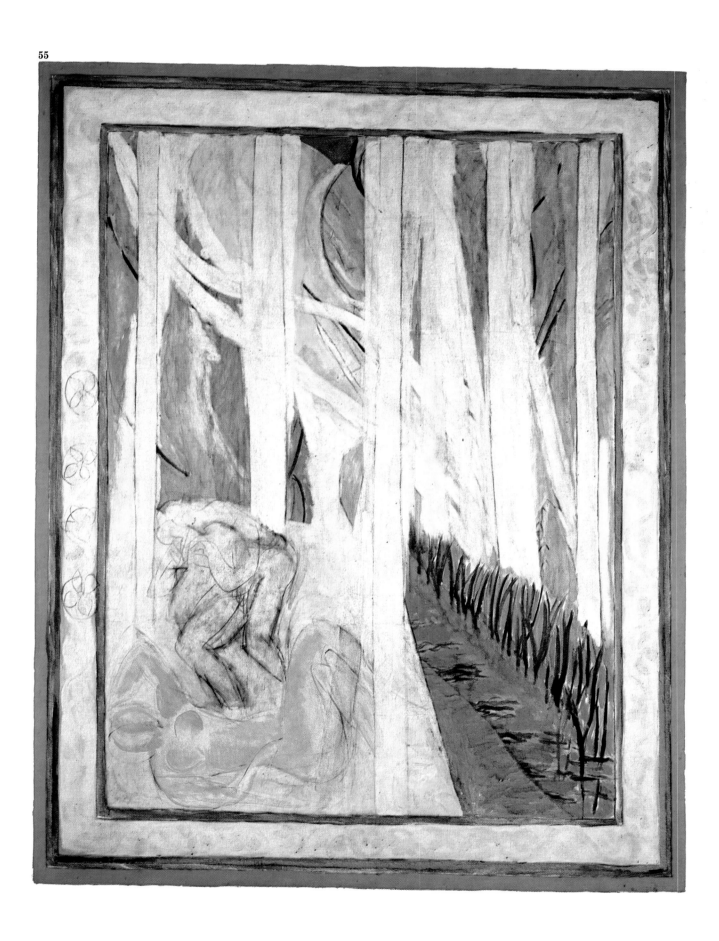

55 Nymph in the Forest (La Verdure), *1935–c. 1942. Reworked over several years, this picture continues the pastoral and mythological themes initiated with* Luxe, calme et volupté *of 1904–5 (plate 8) and* Le Bonheur de vivre *of 1905–6, but represents a much more sober view than the luminous Arcadian fantasies of Matisse's youth.*

56–58 The Blue Blouse, *1936;* Blouse with Armchair, *1936;* The Romanian Blouse, *1940. The ever more schematic treatment of decorative patterns is well demonstrated in these three pictures, especially in* The Romanian Blouse, *where the simplified linear syntax also extends to the figure.*

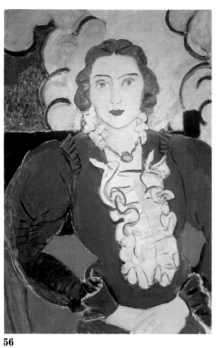

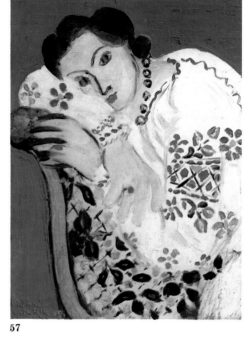

56

57

58

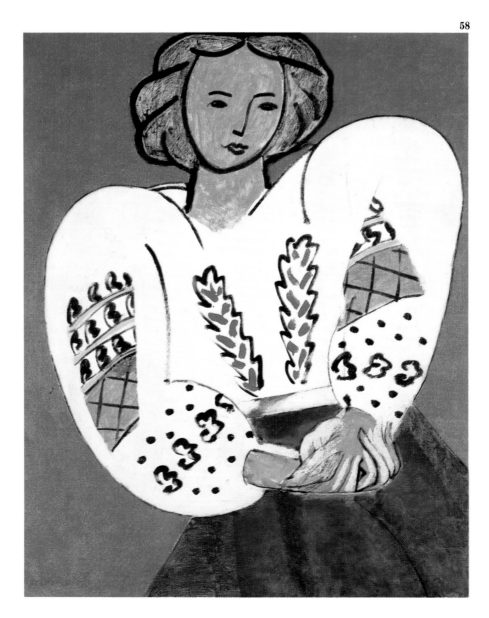

59 Woman in Blue (The Large Blue Robe and Mimosa), *1937. In executing this painting, Matisse was influenced by the portrait of Madame Moitessier by Ingres, and he created visual opulence with simple means. The background is composed of grids, as in* Large Reclining Nude (The Pink Nude) *(plate 54).*

59

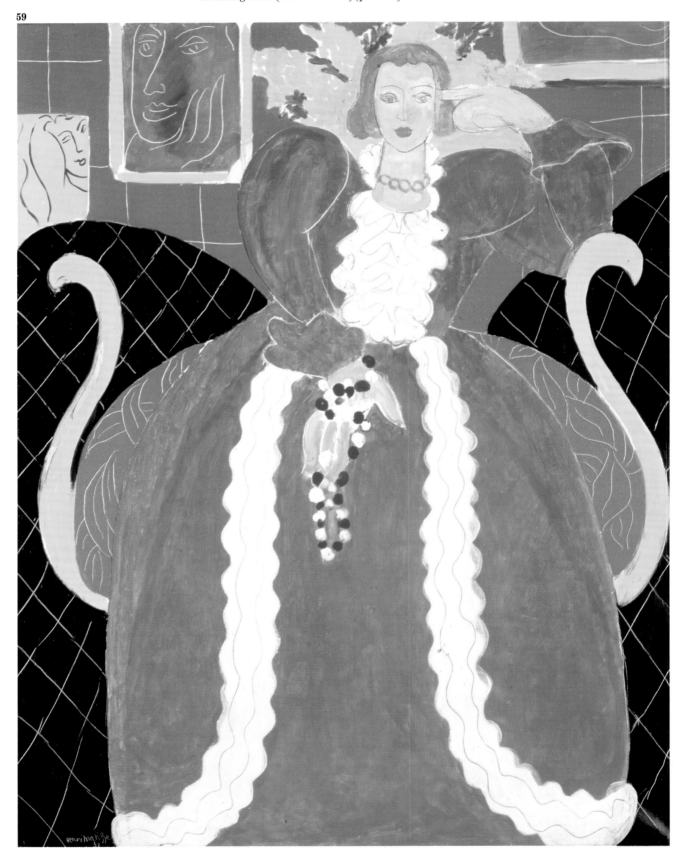

60 Reader on a Black Background (The Pink Table), *1939. The concentrated intimacy of his interiors is more accentuated in these years. The primacy of the surface treatment becomes very overt in spite of the spatial complexity of this scene, where the figure is reflected in the mirror behind her.*

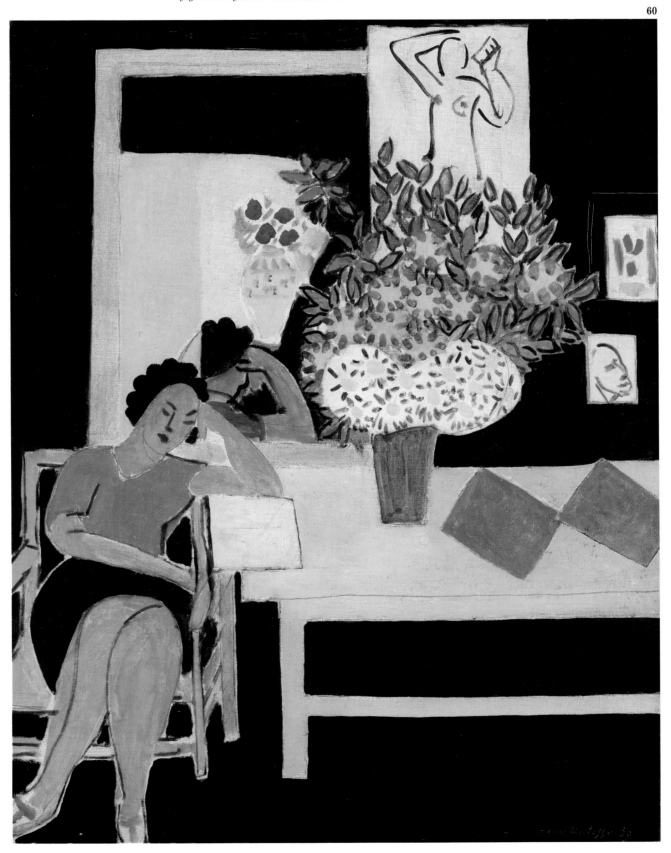

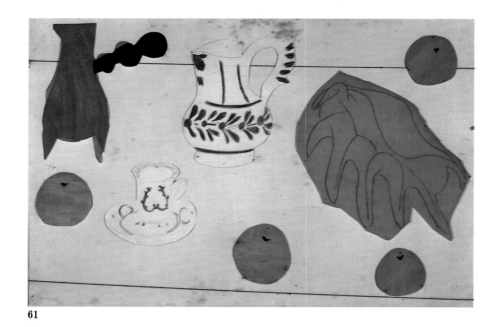

61

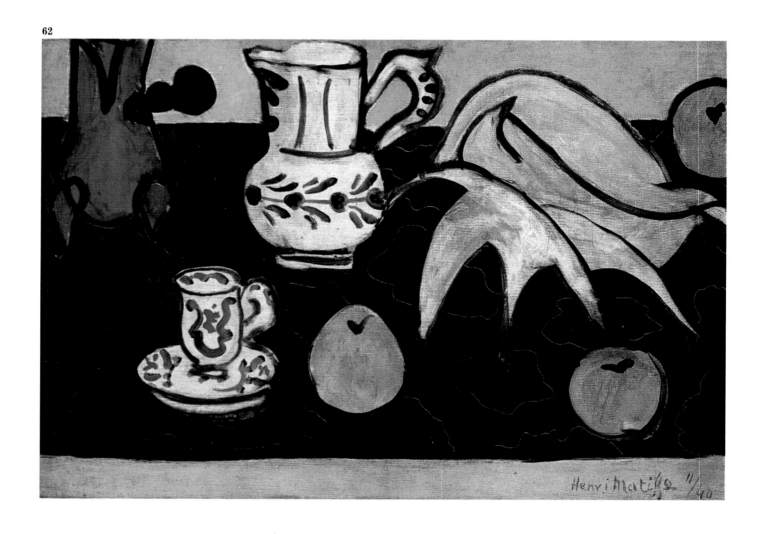

62

61, 62 Still Life with a Seashell and Coffeepot *(cutout), 1941;* Still Life with a Seashell on Black Marble, *1940. The simplification of the subject led to the technique of colored paper cutouts. Proof of it is this still life, painted first in oil in the conventional manner and repeated a year later in the new medium. In the two versions Matisse plays with different ways of establishing a relationship between figure and background.*

63 Jupiter and Leda, *1944 – 45. This work, commissioned by an Argentinean diplomat for a door communicating between his bedroom and bath, is one of Matisse's last forays into mythology. Although initially the subject was to be a satyr looking at a sleeping nymph, the final choice was this abstracted, enigmatic version of the rape of Leda by Jupiter in the form of a swan.*

63

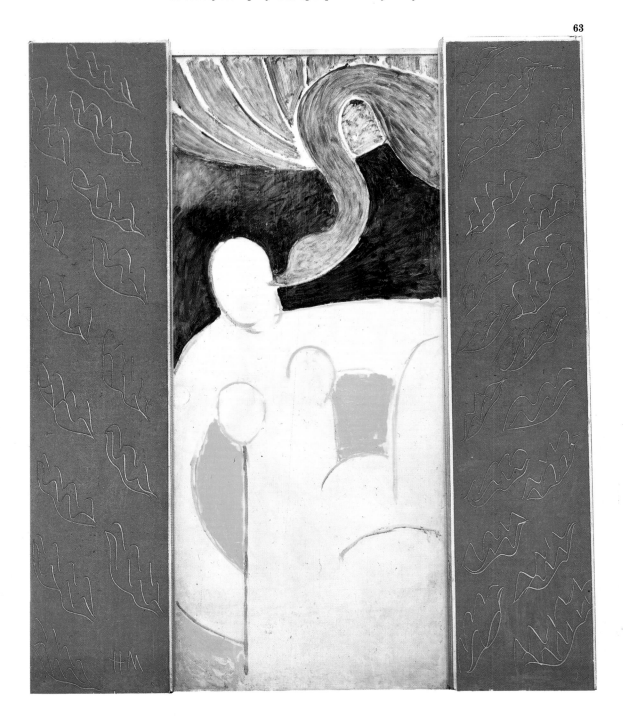

Paper Cutouts

The last fifteen years of Matisse's life were marked by persistent health problems, undoubtedly aggravated by the consequences of World War II and the German Occupation, during which his wife and daughter were jailed for several months. In spite of these setbacks his artistic career did not falter; on the contrary, it was invigorated by the addition of a new technique that played a major role in the last stage of his work. Sheets of paper—colored with gouache and then cut out and pasted onto a support—allowed Matisse to "draw" with scissors and reach his ideal of a flat and schematic pictorial style. He had already used cutouts to prepare the Barnes Foundation *Dance* in 1930, but it was only after 1943, when he began the illustrations for the book *Jazz* (plates 64–69), published in 1947, that this technique became prevalent in the creation of original works. They show that Matisse had remained faithful to the axiom of Maurice Denis, who maintained that a picture, even before the subject that it represents, was first of all "a flat surface covered with colors arranged in a certain order."

64

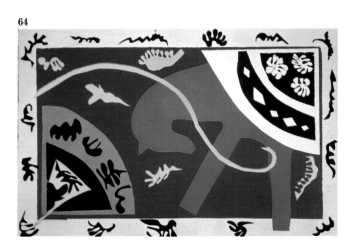

65

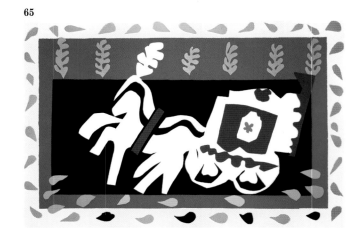

66

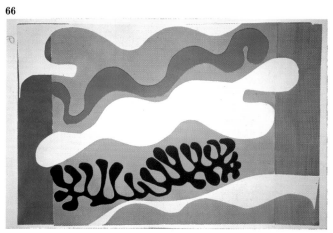

67

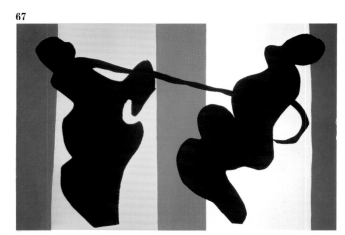

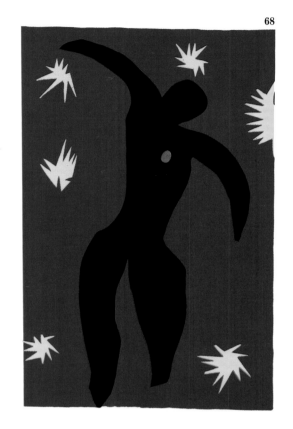

64–69 *Illustrations for* Jazz *(published 1947):* Horse, Horseman, and Clown, *1947;* Pierrot's Burial, *1943;* Lagoon, *1944;* The Cowboy, *1943–44;* Icarus, *1943;* Destiny, *1943–46. The illustrations for* Jazz, *related to circus or fantasy themes, influenced the subjects as well as the composition of the paper cutouts executed from then on. World War II subtly underlies some images, such as* Icarus, *which suggests a flyer downed by enemy fire.*

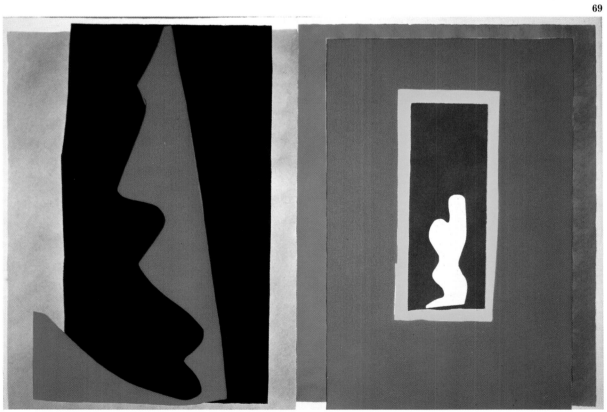

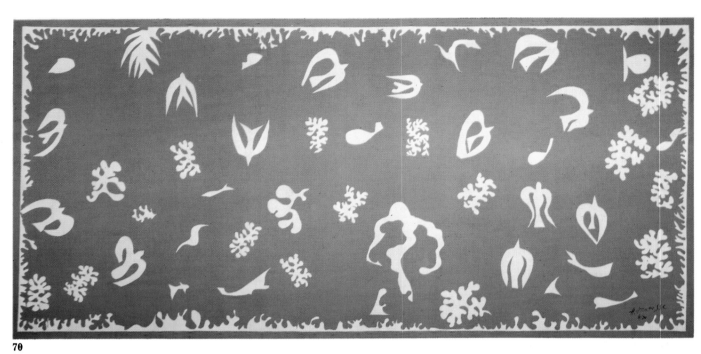

70

71

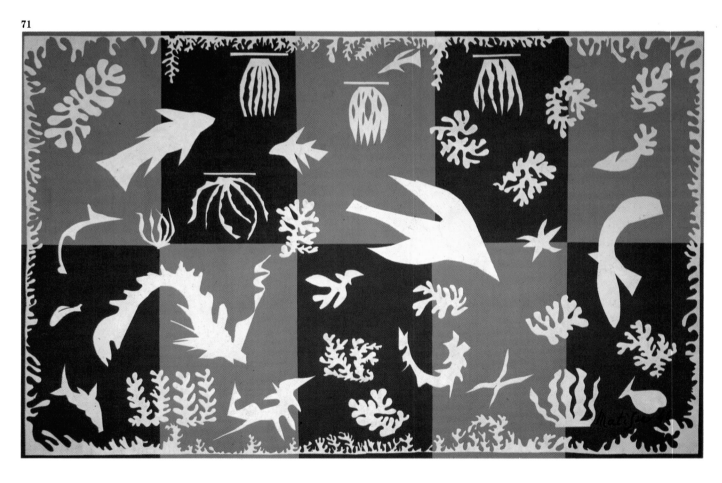

70, 71 Oceania, the Sky, *1946;* Polynesia, the Sea, *1946. Two examples of the decorative uses of paper cutouts: the first is a linen tapestry for Ashley of London; the second is for the Beauvais workshop. Both were inspired by marine and aquatic themes, fruit of Matisse's trip to Tahiti sixteen years earlier, already displayed in his illustration for* Jazz *entitled* Lagoon *(plate 66).*

72 Zulma, *1950. Singular among Matisse's abstract and decorative paper cutouts is this large-format figure, a direct descendant of the central personage in the two versions of* Le Luxe *(plates 18, 19). The background, composed of complementary color planes, and the division of the figure into two halves by a wide orange stripe that sets off the surrounding blue color, recall another emblematic picture from many years earlier,* Portrait of Madame Matisse (The Green Line) *(plate 9), demonstrating once again the underlying unity of Matisse's work.*

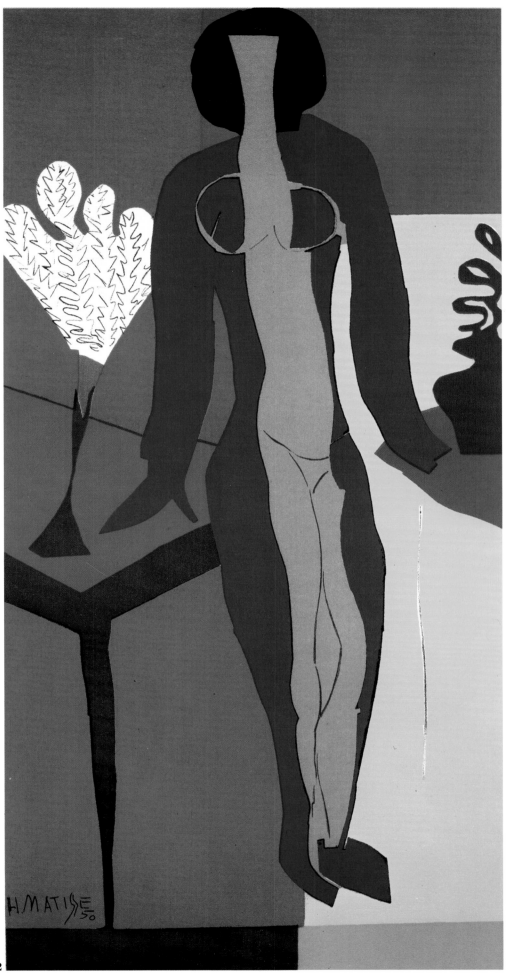

72

73–75 The Beasts of the Sea, *1950;* Mimosa, *1949–51;* The Eskimo, *1947. Plant and marine motifs stylized for decorative purposes predominate in this period, reducing the figurative aspect of the picture to the utmost. The same motifs were used in the stained glass windows for the Chapel of the Rosary at Vence.*

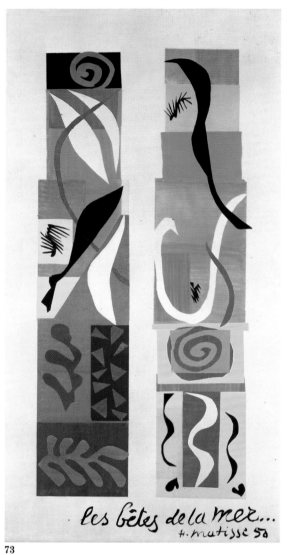

73

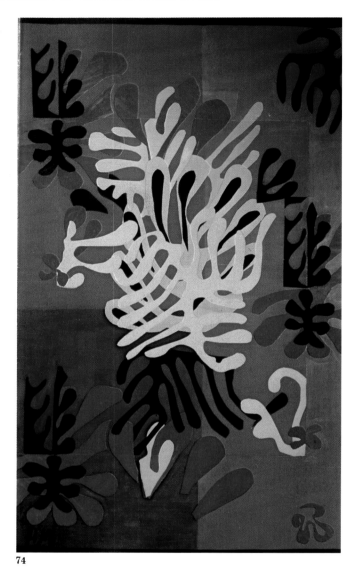

74

75

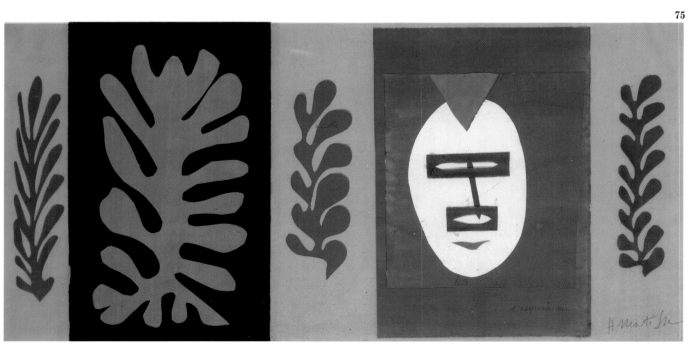

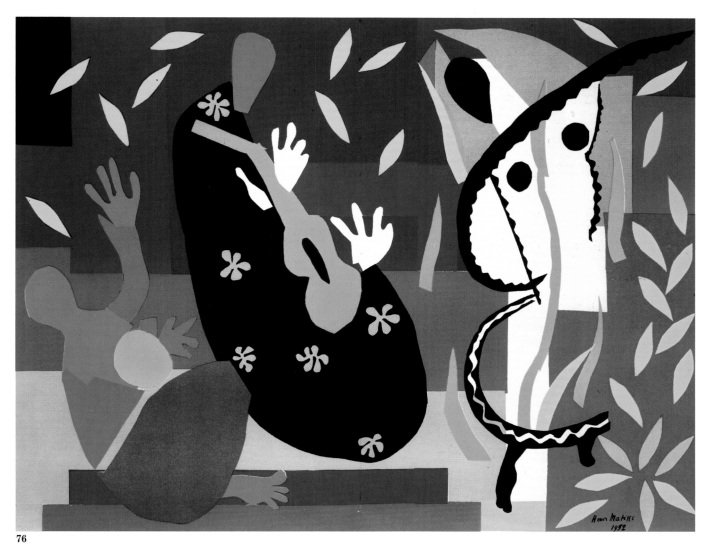

76

76 Sorrow of the King, *1952. Perhaps the last large-format figurative work of Matisse's career.*

77 The Bees, *1948. Matisse's interest in the rhythms of light and color pursued in large-format works surprisingly relates to some American painters of this period, such as Barnett Newman or, later, Frank Stella.*

77

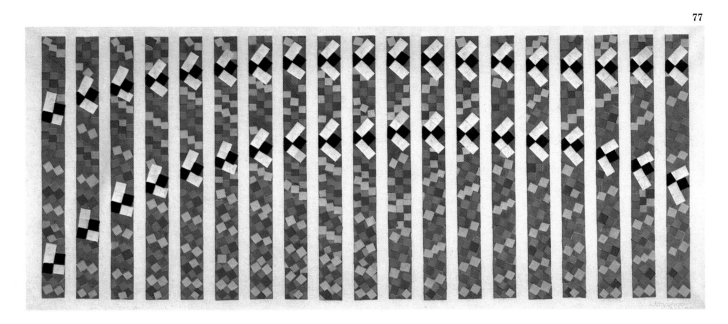

78–81 Memory of Oceania, *1953;* Acrobats, *1952;* The Flowing Hair, *1952;* The Swimming Pool *(detail), 1952. The last of Matisse's paper cutouts achieve a freedom in form and color without equal in his previous work. The audacity of these late works, coming from the hands of an old man who could barely get out of bed, attests to the continued vigor of Matisse's imagination.*

78

79

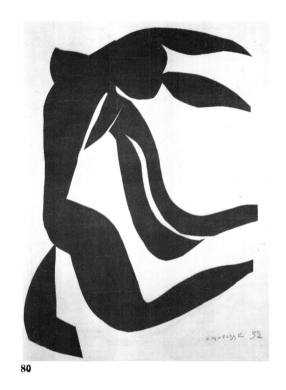

80

81

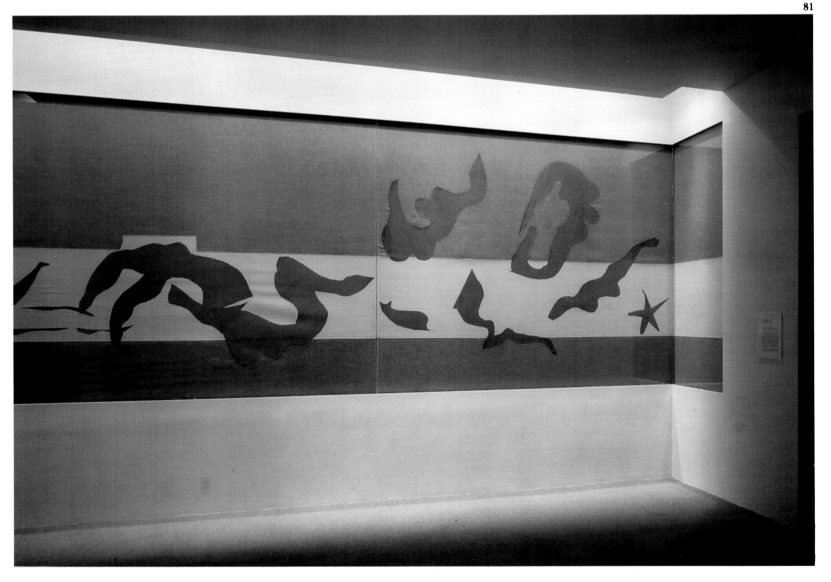

The Chapel of the Rosary, Vence

Near the end of his life, Matisse was invited to decorate a chapel for the Dominican nuns in Vence, in the south of France. The commission fulfilled his desire to create an ambitious decorative work conceived as a unit, in the manner of the great Italian fresco painters of the fourteenth and fifteenth centuries—especially Giotto, who had fascinated him for many years. Matisse envisioned a diaphanous space transformed by the colored light from stained glass windows; their radiance is reflected by three large ceramic-tile murals representing St. Dominic, the Madonna and Child, and the Stations of the Cross. The windows repeat—in a harmony of yellow, green, and blue—the stylized floral motifs of the paper cutouts, making reference to the theme of the Tree of Life. Matisse also designed the liturgical objects for the chapel, approaching with unusual enthusiasm a task undertaken as more than a commission: it was the artistic and spiritual legacy of a man aware that he was working on his last masterpiece.

82 Madonna and Child *(ceramic-tile mural), 1949–50. The tile panels reflect light from the stained glass windows on the side wall.*

83 The Stations of the Cross *(ceramic-tile mural), 1949–50. The simultaneous presentation of the various Passion scenes conveys a general emotional impression rather than a step-by-step narrative.*

84 The Tree of Life *(stained glass window), 1949–50. Matisse here uses the motifs as well as the technical lessons of the paper cutouts. Color is used to generate light.*

82
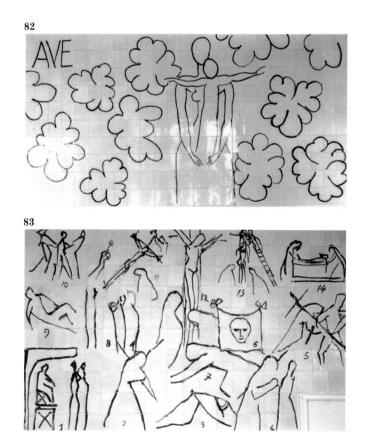

83

84
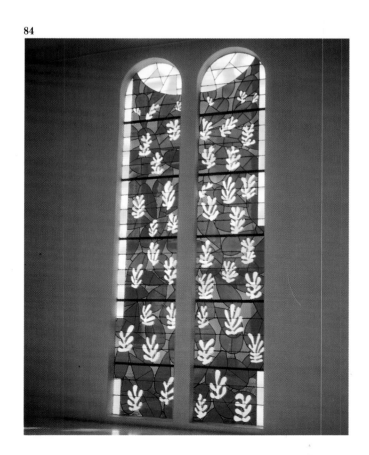

85, 86 *Interior views of the Chapel of the Rosary, Vence, completed 1951. The color harmony comes from the tinted light of the stained glass windows bathing the reflective surfaces, thus extending the viewer's sense of space outward, toward the sky, and suggesting an idea of the sacred. Matisse said: "The light made up of colors [from the windows] is intended to play on the black-and-white stenciled surface of the wall. . . . The contrast makes light the essential element, coloring, warming, and animating the whole structure, to which it is desired to give an impression of boundless space despite the chapel's small dimensions."*

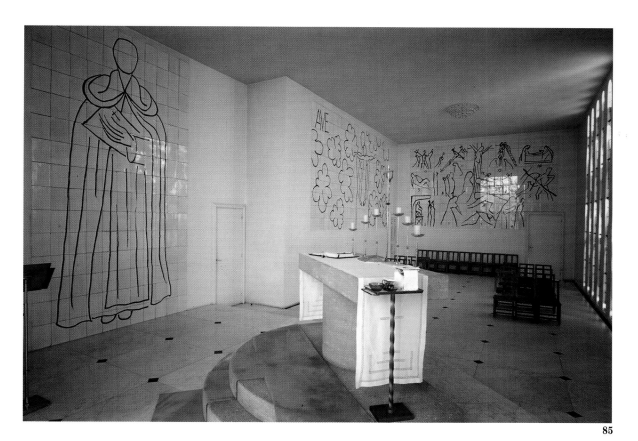

85

86

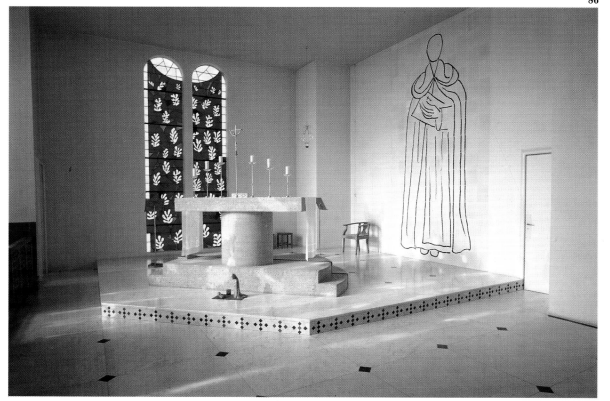

List of Plates

1 The Dinner Table (La Desserte), 1896–97. Oil on canvas, 39³⁄₈ × 51¹⁄₂″ (100 × 131 cm). Private collection

2 Still Life with Books, 1890. Oil on canvas, 15 × 17³⁄₄″ (38 × 45 cm). Private collection

3 La Desserte (after Jan Davidz. de Heem), 1893. Oil on canvas, 28³⁄₄ × 39³⁄₈″ (73 × 100 cm). Musée Matisse, Nice-Cimiez

4 Interior with a Top Hat, 1896. Oil on canvas, 31¹⁄₂ × 37¹⁄₂″ (80 × 95 cm). Private collection

5 Male Model, c. 1900. Oil on canvas, 39¹⁄₈ × 28⁵⁄₈″ (99.3 × 72.7 cm). The Museum of Modern Art, New York. Kay Sage Tanguy and Abby Aldrich Rockefeller Funds

6 Girl with a Parasol, 1905. Oil on canvas, 18¹⁄₈ × 15″ (46 × 38 cm). Musée Matisse, Nice-Cimiez

7 La Japonaise (Woman Beside the Water), 1905. Oil and pencil on canvas, 13⁷⁄₈ × 11¹⁄₈″ (35.2 × 28.2 cm). The Museum of Modern Art, New York. Purchase and partial anonymous gift

8 Luxe, calme et volupté, 1904–5. Oil on canvas, 38¹⁄₂ × 46¹⁄₂″ (98.5 × 118 cm). Musée d'Orsay, Paris

9 Portrait of Madame Matisse (The Green Line), 1905. Oil on canvas, 16 × 12⁷⁄₈″ (40.5 × 32.5 cm). Statens Museum for Kunst, Copenhagen. J. Rump Collection

10 Portrait of Madame Matisse, 1913. Oil on canvas, 57 × 38¹⁄₈″ (145 × 97 cm). The Hermitage Museum, St. Petersburg

11 The Woman with the Hat, 1905. Oil on canvas, 31³⁄₄ × 23¹⁄₂″ (80.6 × 59.7 cm). Private collection

12 Pink Onions, 1906. Oil on canvas, 18¹⁄₈ × 21⁵⁄₈″ (46 × 55 cm). Statens Museum for Kunst, Copenhagen. J. Rump Collection

13 The Young Sailor (I), 1906. Oil on canvas, 39¹⁄₄ × 32¹⁄₄″ (100 × 82 cm). Collection Sign Welhaven, Oslo

14 The Young Sailor (II), 1906. Oil on canvas, 40 × 32³⁄₄″ (101.5 × 83 cm). The Jacques and Natasha Gelman Collection

15 Game of Bowls, 1908. Oil on canvas, 44⁵⁄₈ × 57″ (113.5 × 145 cm). The Hermitage Museum, St. Petersburg

16 Bathers with a Turtle, 1908. Oil on canvas, 70¹⁄₂″ × 7′ 3³⁄₄″ (179.1 × 220.3 cm). The St. Louis Art Museum. Gift of Mr. and Mrs. Joseph Pulitzer, Jr.

17 Nymph and Satyr, 1908–9. Oil on canvas, 35 × 46″ (89 × 117 cm). The Hermitage Museum, St. Petersburg

18 Le Luxe (I), 1907. Oil on canvas, 6′ 10⁵⁄₈″ × 54³⁄₈″ (210 × 138 cm). Musée National d'Art Moderne, Centre Georges Pompidou, Paris

19 Le Luxe (II), 1907–8. Casein on canvas, 6′ 10¹⁄₂″ × 54³⁄₈″ (209.5 × 138 cm). Statens Museum for Kunst, Copenhagen. J. Rump Collection

20 Harmony in Red (La Desserte), 1908. Oil on canvas, 70⁷⁄₈″ × 7′ 2⁵⁄₈″ (180 × 200 cm). The Hermitage Museum, St. Petersburg

21 Interior with Aubergines, 1911. Watercolor on paper, 8³⁄₈ × 9¹⁄₈″ (21.4 × 23.2 cm). Private collection

22 Interior with Aubergines, 1911. Distemper on canvas, 6′ 10³⁄₄″ × 8′ ⁷⁄₈″ (216 × 246 cm). Musée de Grenoble. Gift of the artist, in the name of his family

23 Still Life with Geraniums, 1910. Oil on canvas, 37¹⁄₄ × 45⁵⁄₈″ (94.5 × 116 cm). Neue Pinakothek, Munich

24 The Painter's Family. 1911. Oil on canvas, 56¹⁄₄″ × 6′ 4³⁄₄″ (143 × 194 cm). The Hermitage Museum, St. Petersburg

25 Music, 1910. Oil on canvas, 8′ 5⁵⁄₈″ × 12′ 9¹⁄₄″ (260 × 389 cm). The Hermitage Museum, St. Petersburg

26 Dance (II), 1910. Oil on canvas, 8′ 5⁵⁄₈″ × 12′ 9¹⁄₂″ (260 × 391 cm). The Hermitage Museum, St. Petersburg

27 Dance (I), 1909. Oil on canvas, 8′ 6¹⁄₂″ × 12′ 9¹⁄₂″ (259.7 × 390.1 cm). The Museum of Modern Art, New York. Gift of Nelson A. Rockefeller in honor of Alfred H. Barr, Jr.

28 Dance, 1938. Paper cutouts fastened with pins, 31¹⁄₂ × 25⁵⁄₈″ (80 × 65 cm). Private collection

29 Dance (oil sketch), 1930. Oil on canvas, 13 × 34¹⁄₄″ (33 × 87 cm). Musée Matisse, Nice-Cimiez

30 Dance (first version), 1931–32. Oil on canvas, three panels: 11′ 2″ × 12′ 8³⁄₈″ (340 × 387 cm); 11′ 8¹⁄₂″ × 16′ 4″ (355 × 498 cm); 10′ 11″ × 12′ 10″ (333 × 391 cm). Musée d'Art Moderne de la Ville de Paris

31 The Moroccan Café, 1912–13. Oil on canvas, 69¹⁄₄″ × 6′ 10³⁄₈″ (176 × 210 cm). The Hermitage Museum, St. Petersburg

32 The Standing Riffian, 1913. Oil on canvas, 57⁵⁄₈ × 38¹⁄₂″ (146.5 × 97.7 cm). The Hermitage Museum, St. Petersburg

33 On the Terrace, 1912–13. Oil on canvas, 45¹⁄₄ × 39³⁄₈″ (115 × 100 cm). The Pushkin Museum of Fine Arts, Moscow

34 The Casbah Gate, 1912–13. Oil on canvas, 45³⁄₈ × 31¹⁄₂″ (116 × 80 cm). The Pushkin Museum of Fine Arts, Moscow

35 Odalisque with Red Culottes, 1921. Oil on canvas, 26³⁄₈ × 35¹⁄₈″ (67 × 84 cm). Musée National d'Art Moderne, Centre Georges Pompidou, Paris

36 Odalisque with Gray Culottes, 1921. Oil on canvas, 21¹⁄₄ × 25¹⁄₂″ (54 × 65 cm). Musée de l'Orangerie, Paris. Collection Walter-Guillaume

37 Odalisque with Raised Arms, 1923. Oil on canvas, 25⁵⁄₈ × 19³⁄₄″ (65 × 50 cm). National Gallery of Art, Washington, D.C. Chester Dale Collection

38 The Moroccans, 1915–16. Oil on canvas, 71³⁄₈″ × 9′ 2″ (181.3 × 279.4 cm). The Museum of Modern Art, New York. Gift of Mr. and Mrs. Samuel A. Marx

39 Piano Lesson, 1916. Oil on canvas, 8′ ¹⁄₂″ × 6′ 11³⁄₄″ (245.1 × 212.7 cm). The Museum of Modern Art, New York. Mrs. Simon Guggenheim Fund

40 Bathers by a River, *1909–16. Oil on canvas, 8′ 7″ × 12′ 10″ (261.8 × 391.4 cm). The Art Institute of Chicago. Charles H. and Mary F. S. Worcester Collection*

41 French Window at Collioure, *1914. Oil on canvas, 45⁷⁄₈ × 35″ (116.5 × 89 cm). Musée National d'Art Moderne, Centre Georges Pompidou, Paris*

42 The Yellow Curtain, *c. 1915. Oil on canvas, 57¹⁄₂ × 38¹⁄₈″ (146 × 97 cm). Stephen Hahn Collection, New York*

43 The Red Studio, *1911. Oil on canvas, 71¹⁄₄″ × 7′ 2¹⁄₄″ (181 × 219.1 cm). The Museum of Modern Art, New York. Mrs. Simon Guggenheim Fund*

44 Basket of Oranges, *1912. Oil on canvas, 37 × 32⁵⁄₈″ (94 × 83 cm). Musée Picasso, Paris*

45 Woman in a Turban (Lorette), *1917. Oil on canvas, 32 × 25³⁄₄″ (81.3 × 65.4 cm). The Baltimore Museum of Art. The Cone Collection, formed by Dr. Claribel Cone and Miss Etta Cone, Baltimore, Maryland*

46 Lorette with a Coffee Cup, *1917. Oil on canvas, 36¹⁄₄ × 28³⁄₄″ (92 × 73 cm). Kunstmuseum, Solothurn. Dübi-Müller Collection*

47 Interior with an Egyptian Curtain, *1948. Oil on canvas, 45³⁄₄ × 35¹⁄₈″ (116.2 × 89.2 cm). The Phillips Collection, Washington, D.C.*

48 Large Red Interior, *1948. Oil on canvas, 57¹⁄₂ × 38¹⁄₄″ (146 × 97 cm). Musée National d'Art Moderne, Centre Georges Pompidou, Paris*

49 The Open Window, *1905. Oil on canvas, 21³⁄₄ × 18¹⁄₈″ (55.2 × 46 cm). Collection Mrs. John Jay Whitney*

50 Interior with a Violin, *1917–18. Oil on canvas, 45³⁄₄ × 35³⁄₁₆″ (116 × 89 cm). Statens Museum for Kunst, Copenhagen. J. Rump Collection*

51 Interior with a Phonograph, *1924. Oil on canvas, 34⁵⁄₈ × 31¹⁄₂″ (100.5 × 81 cm). Private collection, New York*

52 The Ballerina, *1927. Oil on canvas, 31⁷⁄₈ × 23⁷⁄₈″ (81 × 60.7 cm). The Baltimore Museum of Art. The Cone Collection, formed by Dr. Claribel Cone and Miss Etta Cone, Baltimore, Maryland*

53 Woman with a Veil, *1927. Oil on canvas, 24¹⁄₄ × 19³⁄₄″ (61.5 × 50.2 cm). The Museum of Modern Art, New York. The William S. Paley Collection*

54 Large Reclining Nude (The Pink Nude), *1935. Oil on canvas, 26 × 36¹⁄₂″ (66 × 92.7 cm). The Baltimore Museum of Art. The Cone Collection, formed by Dr. Claribel Cone and Miss Etta Cone, Baltimore, Maryland*

55 Nymph in the Forest (La Verdure), *1935–c. 1942. Oil on canvas, 7′ 8¹⁄₄″ × 6′ 4³⁄₄″ (242 × 195 cm). Musée Matisse, Nice-Cimiez*

56 The Blue Blouse, *1936. Oil on canvas, 36¹⁄₄ × 23⁵⁄₈″ (92 × 60 cm). Collection Mr. and Mrs. Harry Bahwin*

57 Blouse with Armchair, *1936. Oil on canvas, 8⁵⁄₈ × 6¹⁄₄″ (22 × 16 cm). Private collection*

58 The Romanian Blouse, *1940. Oil on canvas, 36¹⁄₄ × 28¹⁄₄″ (92 × 73 cm). Musée National d'Art Moderne, Centre Georges Pompidou, Paris*

59 Woman in Blue (The Large Blue Robe and Mimosa), *1937. Oil on canvas, 36¹⁄₂ × 29″ (92.7 × 73.6 cm). Philadelphia Museum of Art. Gift of Mrs. John Wintersteen*

60 Reader on a Black Background (The Pink Table), *1939. Oil on canvas, 36¹⁄₄ × 29″ (92 × 73 cm). Musée National d'Art Moderne, Centre Georges Pompidou, Paris*

61 Still Life with a Seashell and Coffeepot, *1941. Cut-and-pasted paper over canvas, 23⁵⁄₈ × 32″ (60 × 81.3 cm). Pierre Matisse Gallery, New York*

62 Still Life with a Seashell on Black Marble, *1940. Oil on canvas, 21¹⁄₂ × 32″ (54.6 × 81.3 cm). The Pushkin Museum of Fine Arts, Moscow*

63 Jupiter and Leda, *1944 – 45. Oil on board, 72 × 61³⁄₄″ (183 × 157 cm). Private collection*

64 Horse, Horseman, and Clown (illustration for* Jazz), *1947. Gouache on paper, cut and pasted, on canvas, 16³⁄₄ × 25⁷⁄₈″ (42.5 × 65.5 cm). Musée National d'Art Moderne, Centre Georges Pompidou, Paris*

65 Pierrot's Burial (illustration for* Jazz), *1943. Gouache on paper, cut and pasted, on canvas, 17¹⁄₂ × 26″ (44.5 × 66 cm). Musée National d'Art Moderne, Centre Georges Pompidou, Paris*

66 Lagoon (illustration for* Jazz), *1944. Gouache on paper, cut and pasted, on canvas, 17¹⁄₈ × 26³⁄₈″ (43.6 × 67.1 cm). Musée National d'Art Moderne, Centre Georges Pompidou, Paris*

67 The Cowboy (illustration for* Jazz), *1943–44. Gouache on paper, cut and pasted, on canvas, 16⁷⁄₈ × 26³⁄₄″ (43 × 68 cm). Musée National d'Art Moderne, Centre Georges Pompidou, Paris*

68 Icarus (illustration for* Jazz), *1943. Gouache on paper, cut and pasted, 17¹⁄₈ × 13³⁄₈″ (43.4 × 34.1 cm). Musée National d'Art Moderne, Centre Georges Pompidou, Paris*

69 Destiny (illustration for* Jazz), *1943–46. Gouache on paper, cut and pasted, 17¹⁄₂ × 26³⁄₈″ (44.6 × 67.1 cm). Musée National d'Art Moderne, Centre Georges Pompidou, Paris*

70 Oceania, the Sky, *1946. Stencil on linen, 69⁵⁄₈″ × 12′ 1⁵⁄₈″ (177 × 130 cm). Musée National d'Art Moderne, Centre Georges Pompidou, Paris*

71 Polynesia, the Sea, *1946. Cut-and-pasted paper on canvas, 6′ 5¹⁄₈″ × 10′ 3⁵⁄₈″ (196 × 314 cm). Musée National d'Art Moderne, Centre Georges Pompidou, Paris*

72 Zulma, *1950. Gouache on paper, cut and pasted, and crayon, 7′ 9³⁄₄″ × 52³⁄₈″ (238 × 130 cm). Statens Museum for Kunst, Copenhagen. J. Rump Collection*

73 The Beasts of the Sea, *1950. Gouache on paper, cut and pasted, on white paper, 9′ 8³⁄₈″ × 60⁵⁄₈″ (295.5 × 154 cm). National Gallery of Art, Washington, D.C. Ailsa Mellon Bruce Fund*

74 Mimosa *(motif for a tapestry)*, 1949–51. *Gouache on paper, cut and pasted, 58¼ × 38" (148 × 96.5 cm). Ikeda Museum of Twentieth-Century Art, Itoh City*

75 The Eskimo, *1947. Gouache on paper, cut and pasted, 16 × 33⅞" (40.5 × 86 cm). Der Danske Kunstindustrimuseet, Copenhagen*

76 Sorrow of the King, *1952. Gouache on paper, cut and pasted, 9' 7" × 12' 11⅞" (292 × 396 cm). Musée National d'Art Moderne, Centre Georges Pompidou, Paris*

77 The Bees, *1948. Gouache on paper, cut and pasted, 39¾" × 7' 10⅞" (101 × 241 cm). Musée Matisse, Nice-Cimiez*

78 Memory of Oceania, *1953. Gouache on paper, cut and pasted, and charcoal on white paper, 9' 4" × 9' 4⅞" (284.4 × 286.4 cm). The Museum of Modern Art, New York. Mrs. Simon Guggenheim Fund*

79 Acrobats, *1952. Gouache on paper, cut and pasted, and charcoal on white paper, 6' 11¾" × 6' 10½" (213 × 209.7 cm). Collection Matisse family*

80 The Flowing Hair, *1952. Gouache on paper, cut and pasted, on white paper, 42½ × 31½" (110 × 80 cm). Beyeler Collection, Basel*

81 The Swimming Pool *(detail), 1952. Nine-panel mural in two parts: gouache on paper, cut and pasted, on white paper mounted on burlap; panels a–e, 7' 6⅝" × 27' 9½" (230.1 × 847.8 cm); panels f–i, 7' 6⅝" × 26' 1½" (230.1 × 796.1 cm). The Museum of Modern Art, New York. Mrs. Bernard F. Gimbel Fund*

82 Madonna and Child *(ceramic-tile mural), 1949–50. The Chapel of the Rosary, Vence*

83 The Stations of the Cross *(ceramic-tile mural), 1949–50. The Chapel of the Rosary, Vence*

84 The Tree of Life *(stained glass window), 1949–50. The Chapel of the Rosary, Vence*

85, 86 *Interior views of the Chapel of the Rosary, Vence, including the altar and* St. Dominic *(ceramic-tile mural), completed 1951*

Editor, English-language edition: James Leggio
Designer, English-language edition: Judith Michael

Page 1 The Flowing Hair *(illustration for* Poésies de Stéphane Mallarmé*). Lausanne, Skira, 1932. Etching, 13⅛ × 9⅞" (33.2 × 25.3 cm)*

Photographs have been provided in many cases by the owners or custodians of the works, identified in the captions; the following list, which refers to plate numbers, applies to photographs for which a separate acknowledgment is due: Hélène Adant, all rights reserved, 82–86; Artephot, 13; Artephot/Photopress, 22; Artothek, 1, 46, 80; Blauel-Artothek, 23; Cauvin, 2; Artephot/Faillet, 11, 79; Artephot/Plassart, 14, 26, 51, 52; Hans Petersen, 9, 12, 19, 50, 72; Photo-Archive Henri Matisse, 4, 10, 15, 17, 20, 24, 25, 31–34, 49, 56, 57, 64–69; Réunion des Musées Nationaux, 8, 36, 44; Ole Woldbye, 75.

Library of Congress Catalog Card Number: 94–36573
ISBN 0–8109–4685–8

Copyright © 1994 Globus Comunicación, S.A.,
and Ediciones Polígrafa, S.A.
Reproductions copyright © 1994 Succession H. Matisse/L.A.R.A.
English translation copyright © 1995 Harry N. Abrams, Inc.

Published in 1995 by Harry N. Abrams, Incorporated, New York
A Times Mirror Company

Printed and bound in Spain by La Polígrafa, S.L.
Parets del Vallès (Barcelona)
Dep. Leg.: B. 1.892-1995